MAZDA
RACEWAY
LAGUNA SECA

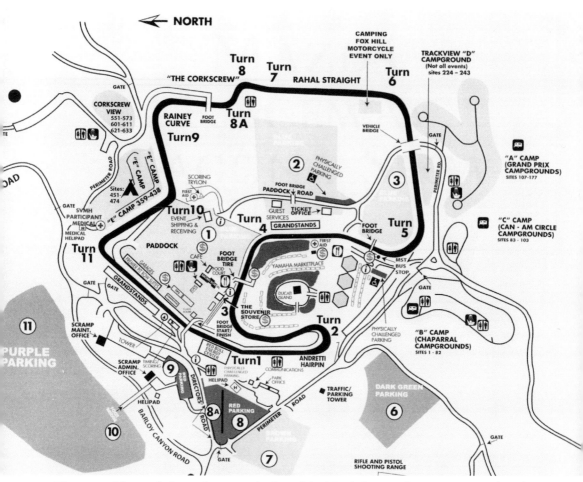

This map of the track shows the entire facility of the Mazda Laguna Seca Raceway and is a huge asset to any fan attending a race for the first time. (Courtesy Mazda Raceway.)

ON THE FRONT COVER: John Surtess works his way through the Corkscrew during the 1966 Can-Am race. (Courtesy Mazda Raceway.)

ON THE COVER BACKGROUND: Fans fill the parking lots at Laguna during a race in the mid-1960s. (Courtesy Mazda Raceway.)

ON THE BACK COVER: The Porsche RS Spyder of Sasha Maassen leads teammate Timo Bernhard during the American Le Mans Series race in 2007. (Courtesy Butch Noble.)

Mazda Raceway Laguna Seca

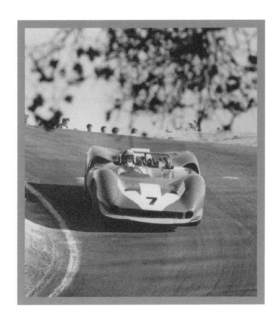

Butch Noble in association with the
Sports Car Racing Association of the Monterey Peninsula

ARCADIA
PUBLISHING

I would like to dedicate this book to all my family,
especially my daughter Emily, and friends.
I could never have done this without you,
and you believed in my ability to do it, even when I had my doubts.

Copyright © 2009 by Butch Noble in association with the Sports Car Racing Association of the Monterey Peninsula
ISBN 978-0-7385-6925-3

Published by Arcadia Publishing
Charleston, South Carolina

Printed in the United States of America

Library of Congress Control Number: 2008938274

For all general information contact Arcadia Publishing at:
Telephone 843-853-2070
Fax 843-853-0044
E-mail sales@arcadiapublishing.com
For customer service and orders:
Toll-Free 1-888-313-2665

Visit us on the Internet at www.arcadiapublishing.com

CONTENTS

ACKNOWLEDGMENTS

Without the blessing of the Sports Car Racing Association of the Monterey Peninsula (SCRAMP) board and the whole staff at Mazda Raceway, this book would never have happened. A special thank-you goes to Greg Curry. Greg allowed me unlimited access to the track's complete photograph archives.

Thanks to my longtime race buddy Chip Oetting for sending me great examples of photographs from his fabulous collection and letting me bounce ideas off of him. Thanks to Keith Rogers for helping with any computer questions, and there were many I came up with. You guys are the best. Thanks also go to Dr. Susan Shavin. I'll never be able to express how much you've helped me.

A special thank-you has to go to Kelly Reed at Arcadia Publishing. She believed in this project from the beginning and was always there to help.

INTRODUCTION

Over 50 years have passed since Mazda Raceway Laguna Seca opened, and in that time, it has become one of the most famous racetracks in the world. Located in Monterey, California, Laguna is actually situated on a small piece of the old Fort Ord U.S. Army base. To this day, most of the access roads leading into the track are lined with barbed-wire fences with signs that warn of unexploded ordnance. Today the track is part of the Monterey County Park System.

The Sports Car Racing Association of the Monterey Peninsula (SCRAMP) handles management and day-to-day operations of major motorsports events. Over the years, SCRAMP has been able to donate millions of dollars to local charities through their operations of the facility.

Before the raceway existed, local road racing was being held on the streets of nearby Pebble Beach. The races grew over the years and attracted tens of thousands of racing fans. At the time, track safety consisted of a few hay bales placed around the track with no barriers between the cars and the trees that surrounded the track. And fans were dangerously close to the action. Then in 1956, the Triumph of driver Warren Frinchaboy had an accident and ran into a tree. He survived the accident but received serious injuries. That same weekend, during Sunday's main race, Ernie McAfee was killed when he also ran his Ferrari into a tree near the edge of the track. After these incidents, it was decided that a new, permanent location for racing was needed. The military at Fort Ord realized how big the races were and together with SCRAMP opened negotiations to build a racetrack on part of the base. In 1957, they signed a lease for five years at the cost of $3,000. Construction of the track cost in the neighborhood of $125,000 and took only 60 days to complete.

The track measured 1.9 miles in length and consisted of nine turns. The first race was held in front of 35,000 fans, had 100 participants, and took place on November 9 and 10, 1957. Pete Lovely, driving a 500 Ferrari Testa Rosa, won this first event. The challenge of Laguna in those early years brought famous drivers from around the world. Names like Moss, Clark, Hill, McLaren, and more flocked to the Monterey track.

In 1988, the track length was increased to 2.2 miles. With the added length came an additional two corners, bringing the number of turns to the current 11. This length was added to bring the track up to requirements set by the International Motorcycle Federation (FIM) and the International Automobile Association (FIA). This allowed the track to stage internationally sanctioned events. While the track itself was going through changes, facilities at the track were vastly improved. Old grandstands were replaced, a new infield area was built, and bridges were added to allow fans better access to both the inside and outside of the track.

Ask any driver who's been around Laguna Seca for the first time what made the biggest impression on them, and they all come up with the same answer: the Corkscrew. Turns eight and eight A present drivers with the largest elevation change in the shortest distance of any racetrack

in the world; drivers approach the turn with a blind crest and then drop the equivalent of four stories in elevation as they work their way down the track. In other words, the bottom drops out. Not only is the section of the track the drivers' favorite, it's also the spectators' favorite, as the area gives them a view unlike any other in the world.

Other parts of the track have been named over the years. Turn two is called the Andretti Hairpin after 1978 World Driving Champion Mario Andretti. The straight between turns six and seven is Rahal Straight for Bobby Rahal, who won four straight Championship Auto Racing Teams (CART) events here between 1984 and 1987. Turn nine has been named Rainey Curve in honor of motorcycle racing great Wayne Rainey.

The track is also home to the world-famous Skip Barber Racing School. The school teaches race and street driving classes year-round.

In addition to motorsports events, the facility holds the annual Sea Otter Classic bicycle race, music concerts, festivals, and more. In September 1987, Pope John Paul II celebrated mass at the track, and 50,000 people gathered to see him.

The track has been used in several Hollywood movies and television shows and has even been used on several racing video games.

THE TRACK

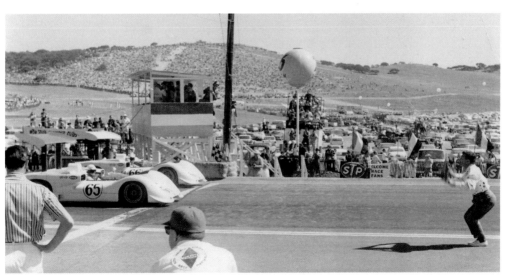

Pictured are people waiting for the start of the 1966 Can-Am race. Phil Hill (No. 65) in Chaparral 2E and Jim Hall (No. 66) wait for the drop of the green flag. A huge crowd sits on the hill; the event drew between 35,000 and 40,000 fans. (Courtesy G. N. Pendelton.)

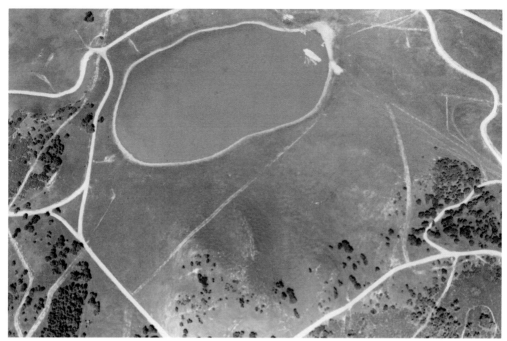

Here is an aerial shot of the property before construction on the track began. Even after the track was built, the lake remained for several years. (Courtesy Mazda Raceway.)

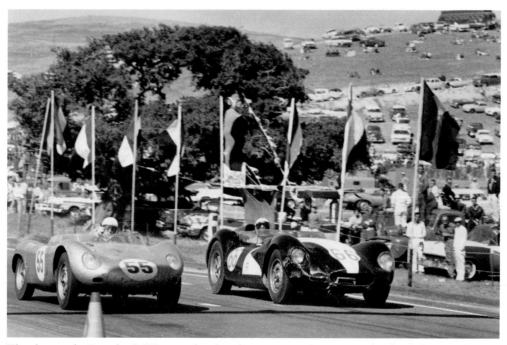

The driver of a Porsche RSK gives the thumbs up sign as he crosses the finish line in the late 1950s, while the driver of the Lister shows some damage sustained during the race. The tree in the background sits where the current pit area is located. (Courtesy Mazda Raceway.)

THE TRACK

This view is looking back down the front straight toward the start/finish line during the mid-1960s. The original pit exit can be seen on the left. (Courtesy Mazda Raceway.)

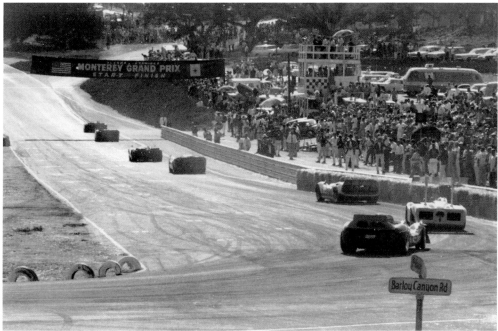

A large crowd watches as a group of big bore sports cars works through turn nine onto the main straight in the late 1960s. The street sign in the foreground gives a bit of an illusion the track is run on city streets. (Courtesy Mazda Raceway.)

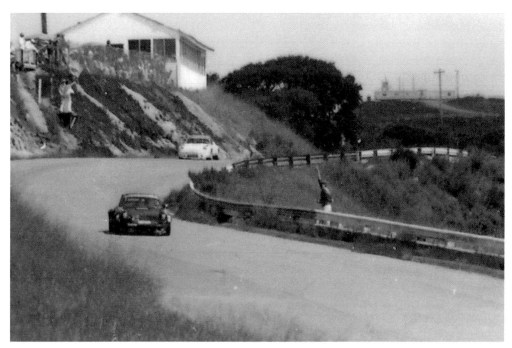

Here is a shot looking back at turn one during the late 1970s. (Courtesy Mazda Raceway.)

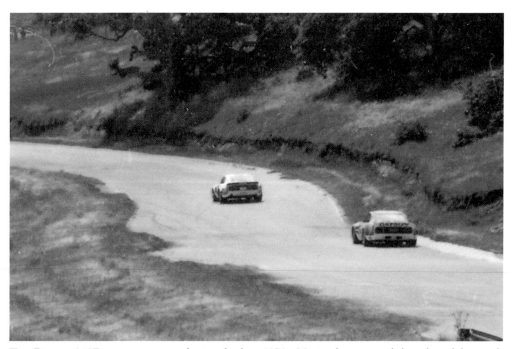

Two Datsun 240Zs enter turn two during the late 1970s. Notice how ragged the edge of the track is—and no safety barriers anywhere. (Courtesy Mazda Raceway.)

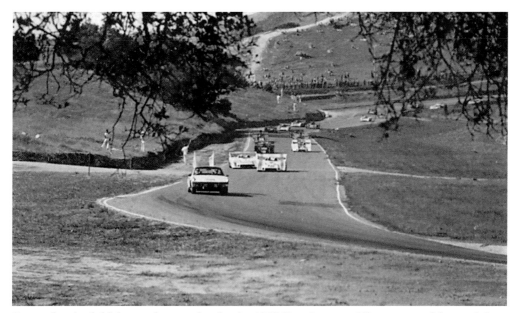

Pictured is the field during the pace lap for the 1973 Can-Am race. The section of the track here was replaced in 1988 and the track length increased from the original 1.9 miles to 2.2 miles. Some of the pavement and curbing from the old layout still exists. The area is used today as a parking lot. (Courtesy Mazda Raceway.)

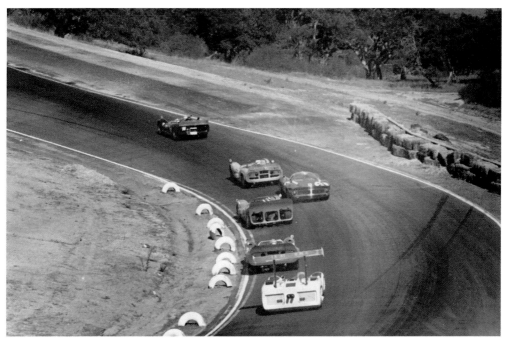

In the late 1960s, a group of cars works their way through turn five. The tires marking the inside of the turn were a big visual help to drivers. But if a driver cut the turn too tight, the tires could tear a car up and knock the driver out of the race. (Courtesy Mazda Raceway.)

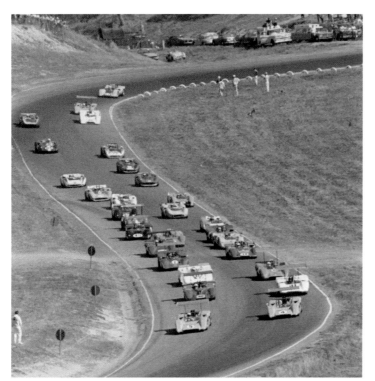

This is another angle of the 1969 Can-Am field on its pace lap. This was the last year that the Can-Am cars were allowed to run the large giant wings seen on several of the cars here. The course workers are out saluting the field, and all the emergency vehicles are in place. Time to go racing! (Courtesy Peter Bersari.)

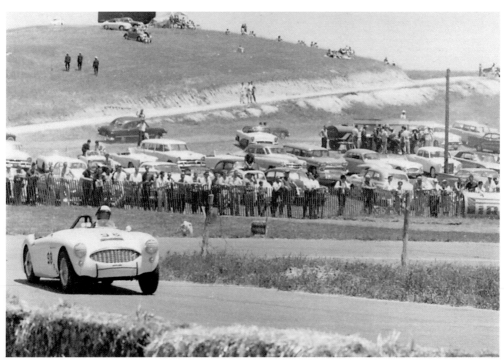

An Austin Healy exits turn nine in the early 1960s. Hay bales and weeds await any driver who happens to go off the track. (Courtesy Mazda Raceway.)

THE TRACK

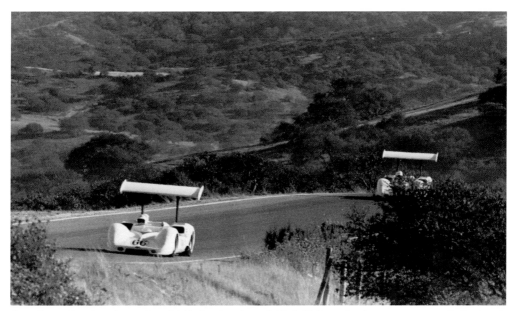

Out for a Sunday drive, Jim Hall (leading) and Phil Hill work their way around the track during the 1966 Can-Am race. This photograph makes the cars look like they could be driving on any public road. Even to this day, Laguna is a favorite with photographers. (Courtesy Mazda Raceway.)

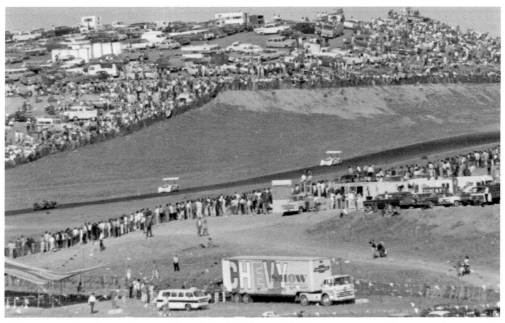

This is another shot of Jim Hall and Phil Hill in 1966. In contrast to the prior photograph, this one shows just how large the crowds were. In the foreground can be seen a semi-truck with "Chevy Show" on the trailer. Even then, car manufacturers brought products to races for customers to see. (Courtesy Mazda Raceway.)

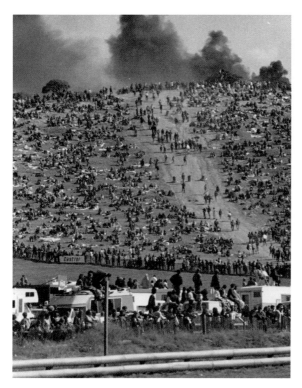

During a Can-Am race in the 1970s, an accident occurred. Race cars crashed through the spectators' fences (luckily with no major injuries) and ended up in a parking area. The cars involved caught on fire, and the resulting smoke can be seen here. (Courtesy Mazda Raceway.)

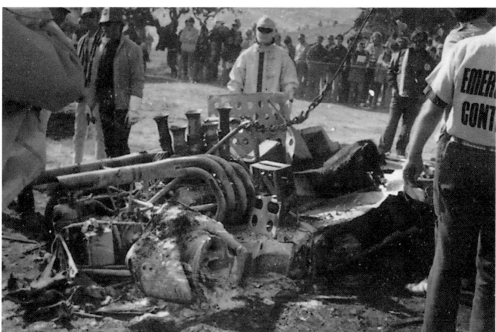

The wreckage of one of the Can-Am McLarens that crashed into a spectators' parking area during the 1971 race is shown here. Laguna's track marshals and fire crews did a fantastic job and kept the damage to a minimum. (Courtesy Mazda Raceway.)

THE TRACK

Jim Hall's Chaparral exits turn eight during practice for the 1968 Can-Am race. When the race was held on Sunday, the hills in the background were covered with spectators. (Courtesy Mazda Raceway.)

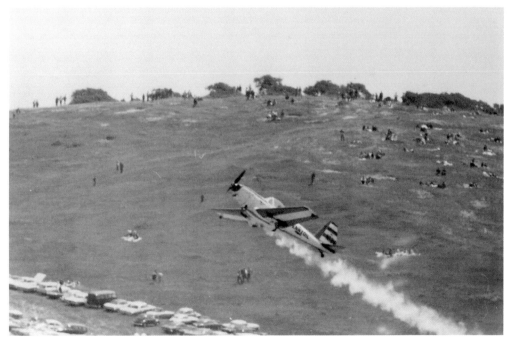

In the late 1960s, air show legend Art Scholl performs for the crowd before a race. (Courtesy Mazda Raceway.)

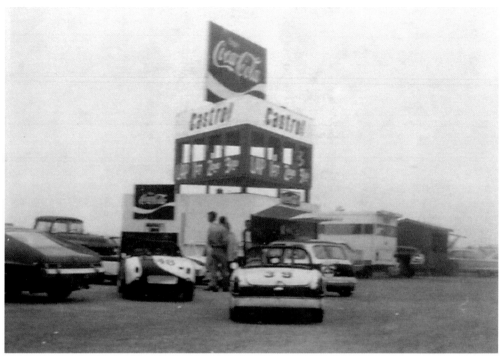

Here is a shot of the track's scoring tower in the early 1970s. (Courtesy Mazda Raceway.)

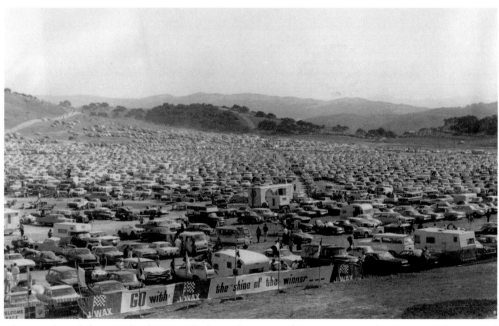

Thousands and thousands of cars pack the parking area during a race in the 1960s. If it happened to rain during a race weekend, this area would completely flood. And traffic after the race could be a nightmare, as there was really only one road to gain access to this area of the track. (Courtesy Mazda Raceway.)

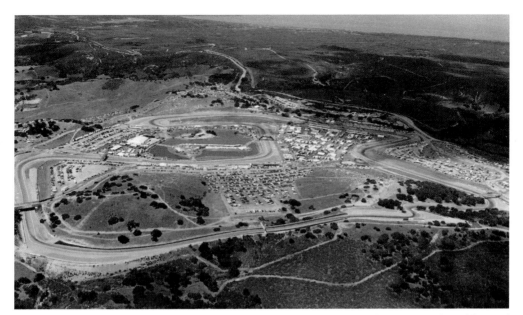

In this overhead shot can be seen the new course layout introduced in 1988. The additional corners can be seen in the middle of the photograph and work their way around the new lake area. With the new addition came larger runoff areas at most corners and more facilities for spectators. (Courtesy Mazda Raceway.)

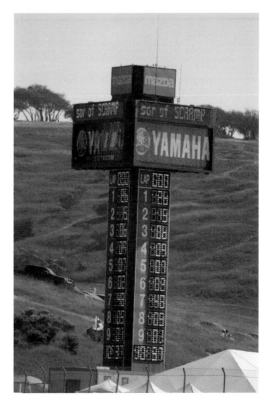

The new scoring tower is viewable from a large portion of the track. The tower not only shows the position of the top machines in a race but also provides much needed information, such as events schedules, across the top. (Courtesy Butch Noble.)

Permanent garages are now located in the paddock area, and just like most baseball and football stadiums, Laguna now has its own luxury boxes located on the upper floor. The garages have roll-up doors on both ends and allow teams to be close to their pit boxes during race events. (Courtesy Butch Noble.)

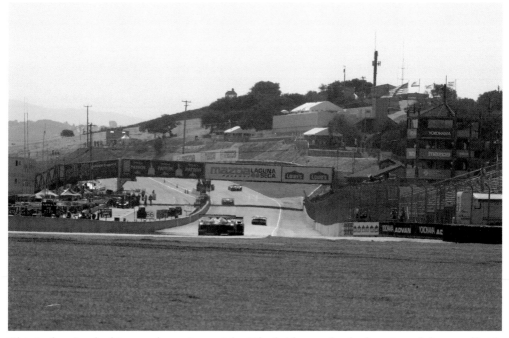

This is the view looking up the main straight. The bridge marks the location of the start/finish line. On the left is the pit lane, and spectator grandstands are behind the fence on the right. (Courtesy Butch Noble.)

THE TRACK

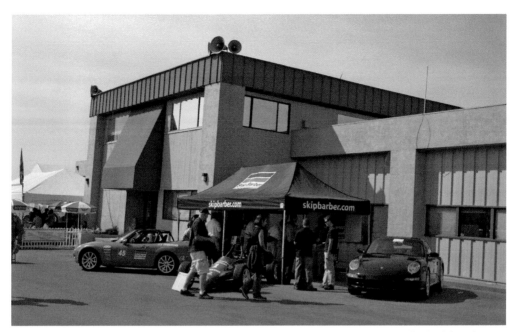

The Skip Barber race school building is located in the main paddock area. The building houses not only the school's classrooms but also their complete racecar storage and maintenance facility. (Courtesy Mazda Raceway.)

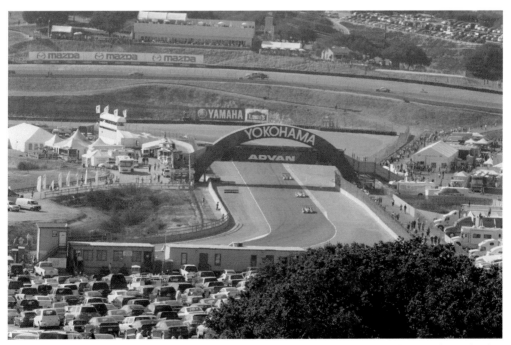

Another view from the top of the hill looks down on turns three and four. The Yokohama bridge allows fans to cross the track from the paddock area on the right to the vendor area on the left. (Courtesy Butch Noble.)

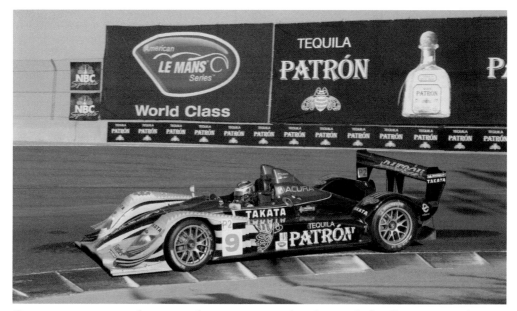

Corporate sponsors are a huge part of any race series today, along with the all-important television package. Having a company willing to not only sponsor a race team but to sponsor actual races is even a bigger plus. This is the top of the Corkscrew during the 2008 American Le Mans Series event. (Courtesy Butch Noble.)

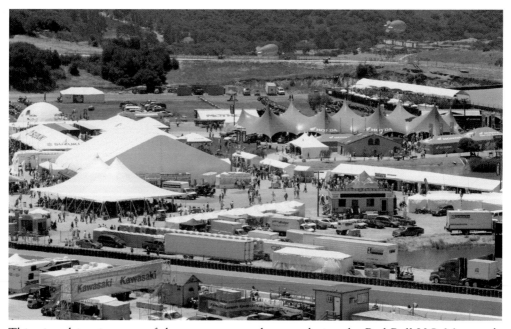

This view shows just part of the enormous vendor area during the Red Bull U.S. Motorcycle Grand Prix, or MotoGP, weekend. All the major motorcycle manufacturers are on hand with all their latest machines. Add that to all the after-market products available and spectators can spend half a day just walking this area. (Courtesy Butch Noble.)

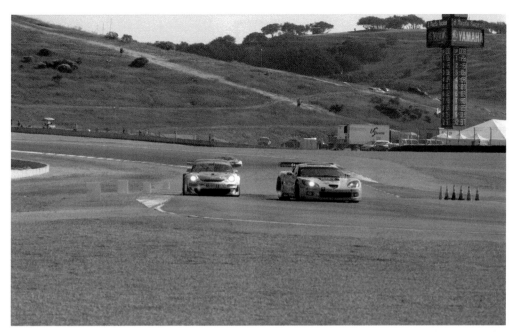

This is the view looking back from turn 11 toward turn 10. The scoring tower can be seen in the background. The cones on the right mark the entrance to pit lane. Large gravel traps slow race cars and motorcycles down in case they run off the track. (Courtesy Butch Noble.)

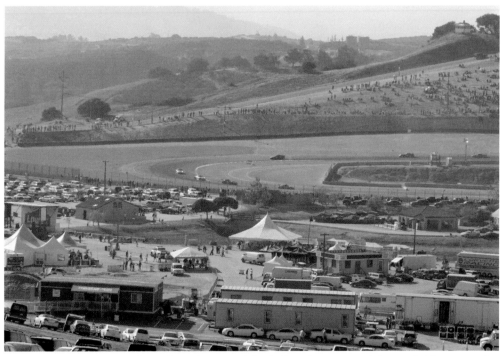

This is the view looking down from the top of the hill in the center of the track. Turn two, the Andretti Hairpin, with its large runoff, can be seen here. (Courtesy Butch Noble.)

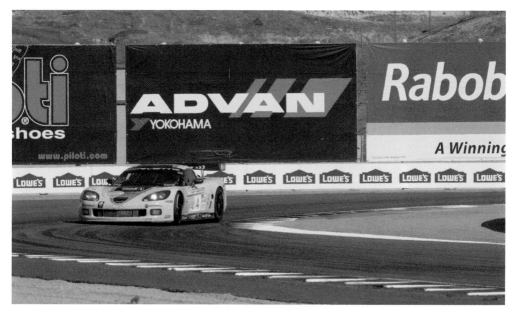

The 2008 ALMS class-winning GT1 Corvette shows the correct way around turn 11. The track's state-of-the-art medical facilities are located behind the billboards. During each race weekend, ambulances are stationed at several locations around the track just in case something happens to go wrong. (Courtesy Butch Noble.)

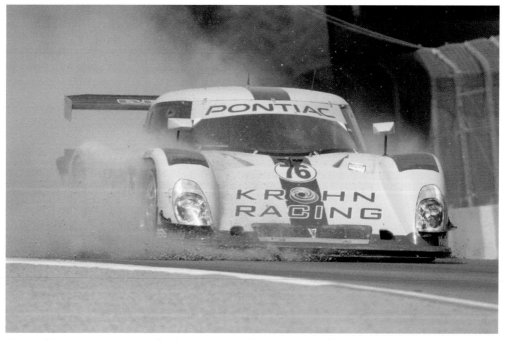

Pictured here is quite a mess for the corner workers. Tracy Krohn's Pontiac Riley spreads gravel across the track during the Grand Am event in 2007. The gravel is meant to slow machines down if they leave the track, but it can create a big mess, as seen here. (Courtesy Butch Noble.)

The Machines

Jim Hall in his Chaparral 2E (No. 66) leads teammate Phil Hill's Chaparral (No. 65) through turn two during the 1966 Can-Am race. Following the two winged wonders is the McLaren M1B-Chevrolet of Bruce McLaren (No. 4), the Lola T-70 Chevrolet of John Surtess (No. 7), and the Lola T-70 Chevrolet of Denny Hulme (No. 8). Hill would win the first of two heat races while Hall finished in second. This was the only time in Can-Am history two Chaparrals finished first and second. (Courtesy Jack Brady.)

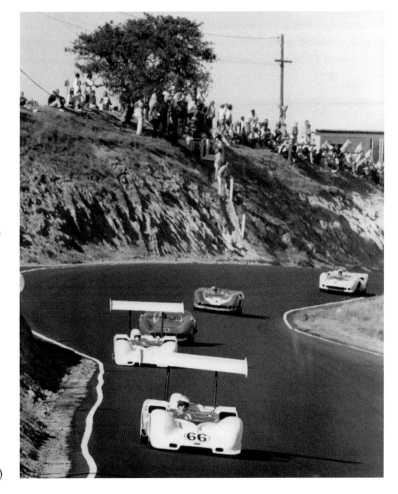

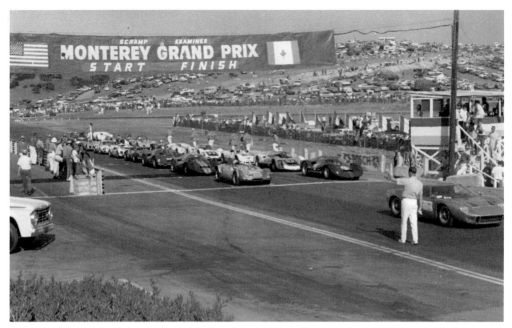

In the mid-1960s, a group of sports cars waits on the grid before the start of the race. The pace car for the race is a Ford GT40, the same type of car that won the 24 Hours of Le Mans several times. (Courtesy Mazda Raceway.)

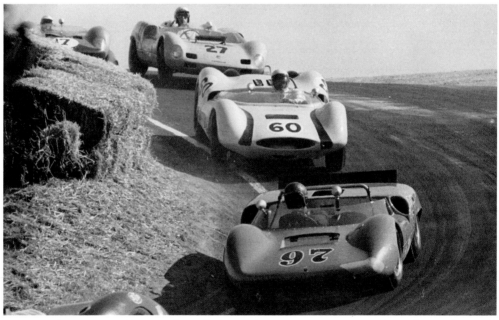

A group of sports racers lines up through the Corkscrew in 1964. Drivers from all over the world came to Laguna in the early years. The track challenged drivers like no other. Hay bales next to the track were meant for safety, but in the event of an accident and fire, the safety device burned right along with the car. (Courtesy Mazda Raceway.)

THE MACHINES

Cars wait on the grid for the 1962 Pacific Grand Prix. On pole position is Roger Penske's Zerex Special. Penske ran to the edge of the Sports Car Club of America rule book with the car. The Zerex was a converted Cooper-Climax F1 car with a larger engine, full bodywork that covered the fenders, and an extra seat (under the bodywork). Penske won the race, along with the previous event at Riverside. After the Laguna race, other competitors complained about whether the car was legal. (Courtesy Mazda Raceway.)

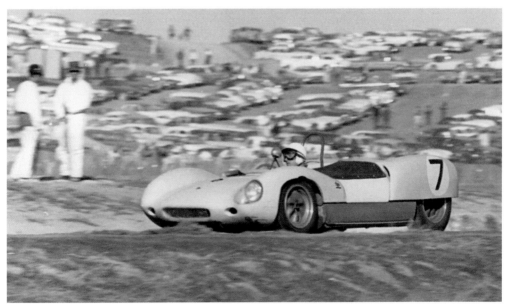

This is a classic shot of Englishman Stirling Moss diving into turn eight in his Lotus during the early 1960s. Moss was one of the most successful drivers of all time, winning many races around the world. To this day, he attends historic races here at Laguna and even took television's Jay Leno for a few laps in a classic Mercedes in 2007. (Courtesy Mazda Raceway.)

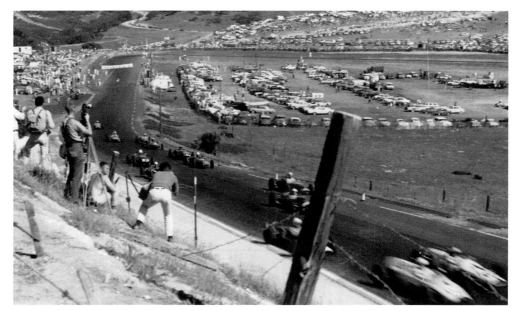

A group of cars roars up the start/finish straight in the early 1960s. Readers can see another example of the lack of safety barriers between the track and spectators, just a fallen down barbed-wire fence. The area where spectators' vehicles are parked in the center of the photograph would become the pit and paddock area within the next few years. (Courtesy Mazda Raceway.)

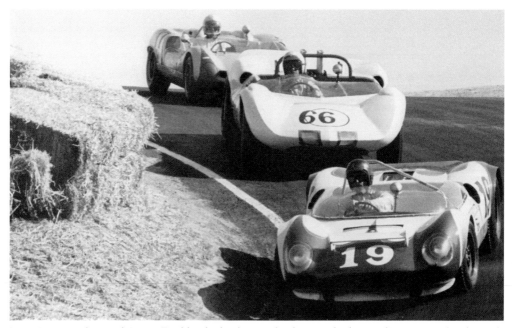

Dan Gurney's (No. 19) Lotus Ford leads the (No. 66) Chaparral Chevy of Roger Penske through the Corkscrew during the 1964 United States Road Racing Championship (USRRC) event. Big-time big-engine sports cars were starting to catch on, and drivers from around the world would come to Laguna to race them. (Courtesy Mazda Raceway.)

THE MACHINES

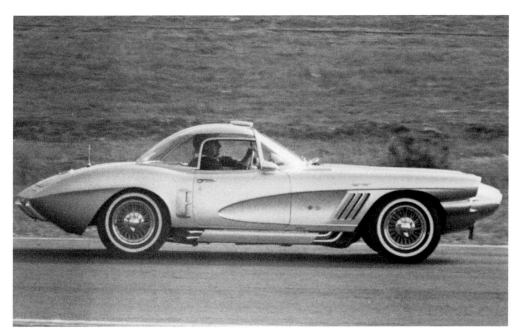

Here is a highly customized 1961 Corvette doing a slow display run around the raceway. As with many customs of the era, the car looks like something out of a period science fiction movie. (Courtesy Mazda Raceway.)

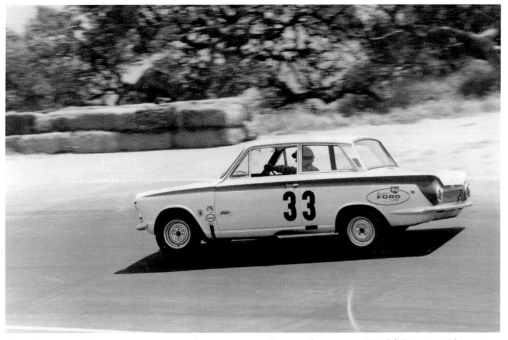

Another great driver comes to give Laguna a try. Future three-time World Driving Champion Jackie Stewart hikes the left front wheel of his Lotus Cortina off the ground in 1965. This event at Laguna was Stewart's first race in the United States. (Courtesy Mazda Raceway.)

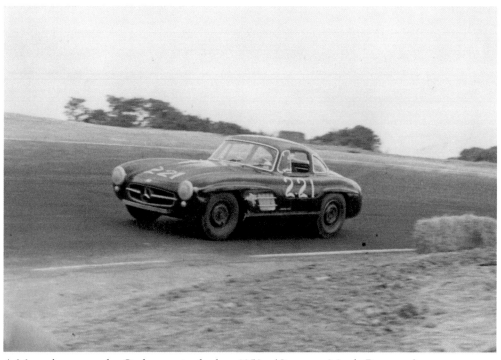

A Mercedes enters the Corkscrew in the late 1950s. (Courtesy Mazda Raceway.)

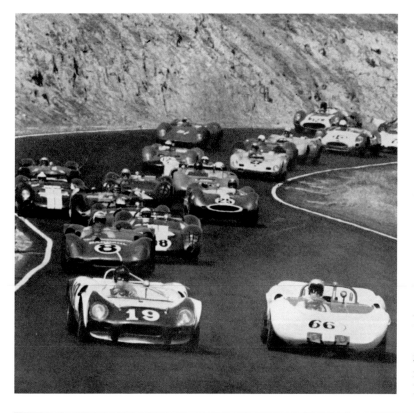

The field works its way between turns one and two during the 1964 USRRC race. Roger Penske, driving his Chaparral (No. 66), would go on to win the race. (Courtesy Mazda Raceway.)

THE MACHINES

In the early 1960s, Richie Ginther's Porsche (No. 60) leads the Porsche of Phil Hill (No. 211) and A. J. Foyt's Buick Scarab (No. 91). Even back then, Porsche was a leader in international sports car racing and relied on smaller-engine, lighter-weight cars to keep up with the larger American V-8-powered machines. (Courtesy Mazda Raceway.)

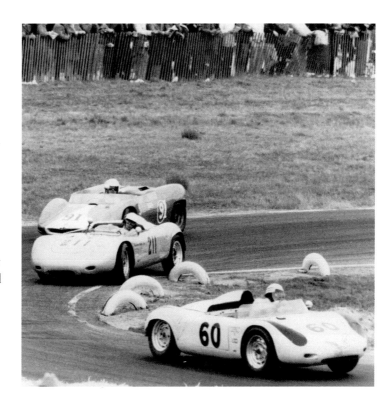

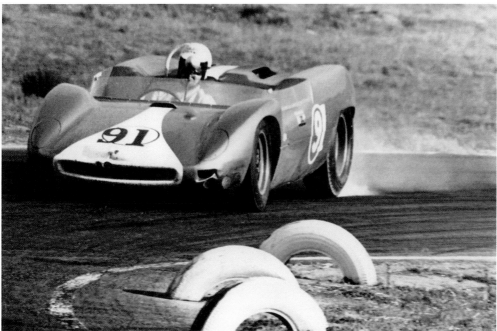

A. J. Foyt locks up his brakes driving a Buick Scarab in the mid-1960s. The challenge of Laguna brought drivers from all types of racing to the Monterey track. Foyt would become the first driver to win the Indy 500 four times. (Courtesy Mazda Raceway.)

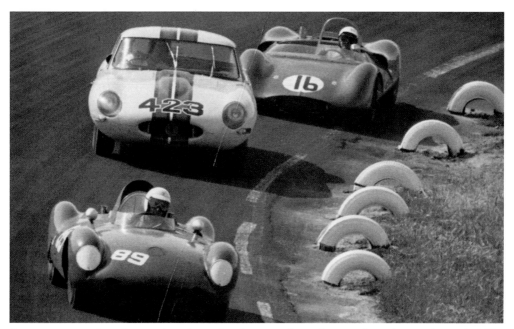

Sports racers and production-based cars battle it out through turn three during the mid-1960s. Notice that in each car, the driver is sitting in a different position—middle, left, and right. (Courtesy Mazda Raceway.)

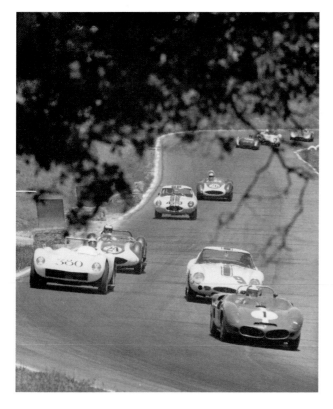

A group of cars including Ferraris, Jaguars, Scarabs, and more negotiate their way between turns two and three in the mid-1960s. (Courtesy Mazda Raceway.)

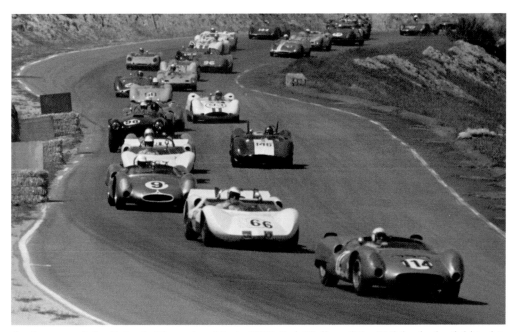

At the start of the Driver's Championship in 1964, Bob Holbert (No. 114) leads the field in his King Cobra, followed by the Chaparral of Jim Hall (No. 66) and Skip Hudson in his Cooper Chevrolet (No. 9). Hall would win the race. (Courtesy Mazda Raceway.)

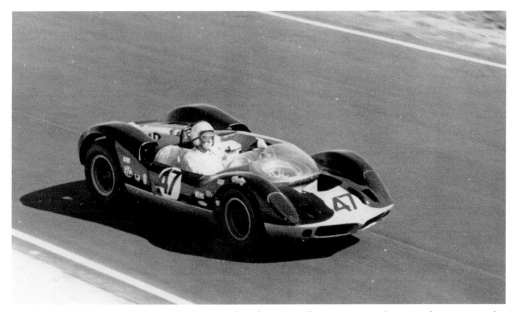

Shown here is Bruce McLaren driving the first complete race car bearing his name, the McLaren M1A Oldsmobile, in 1964. The car was fast and qualified fourth here at Laguna. But various problems during the year meant very few good finishes. McLaren dropped out of this race with water hose problems. Note the spare tire under the front windshield. (Courtesy Mazda Raceway.)

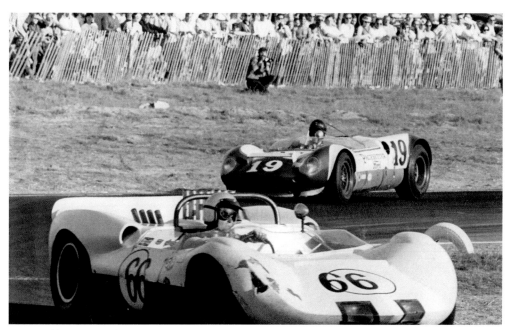

Featured here is another shot of the 1964 USRRC battle between the Chaparral of Roger Penske (No. 66) and the Lotus-Ford belonging to Dan Gurney (No. 19). Penske won the race. But it wasn't easy; notice the damage to the right front of his car. (Courtesy Mazda Raceway.)

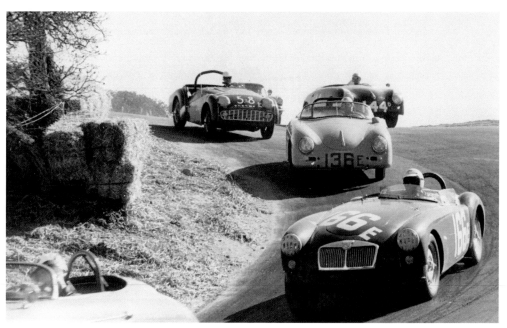

A group of cars races through the Corkscrew in the late 1950s. Just seen leading the way is a Porsche 356 followed by an MGA, another Porsche, a Triumph, and then another Porsche. Small-engine sports cars were very popular at the time, as a driver could buy a car, bolt on a few safety items, and go racing. (Courtesy Mazda Raceway.)

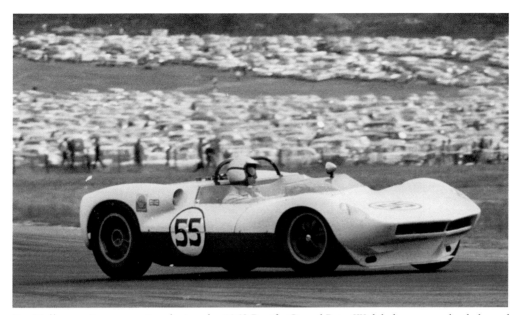

Jim Hall turns into turn nine during the 1963 Pacific Grand Prix. Widely known as the father of racing aerodynamics, Hall, even in 1963, was trying to make the air work for him. A chin spoiler can be seen here along with a cleaner, smoother overall body shape—all in the quest for more speed. (Courtesy Mazda Raceway.)

In the mid-1960s, big-bore production cars were dominated by European manufacturers. Here is a Ferrari leading a Jaguar. The Ferrari in this shot is a 250 GTO, and the Jaguar is an XKE. This model Ferrari has now sold at an auction for up to $20 million! (Courtesy Mazda Raceway.)

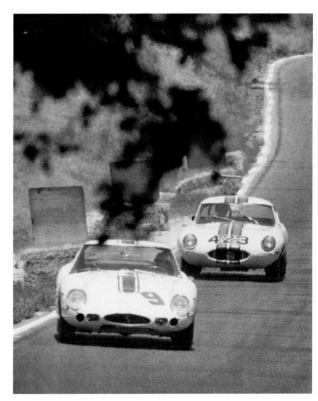

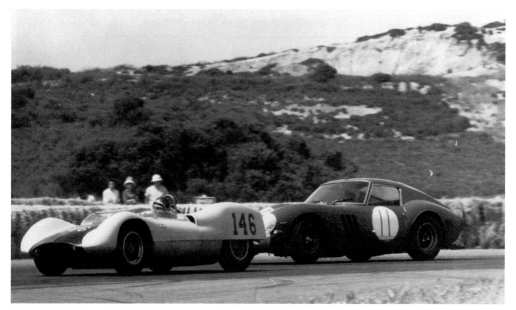

The European manufacturers dominated sports car racing in the early 1960s. This is a Lotus ahead of a Ferrari. Dozens of this vintage Lotus are raced in historic races around the world today. Ferraris, on the other hand, are worth several million dollars. They may be run but not very hard. (Courtesy Mazda Raceway.)

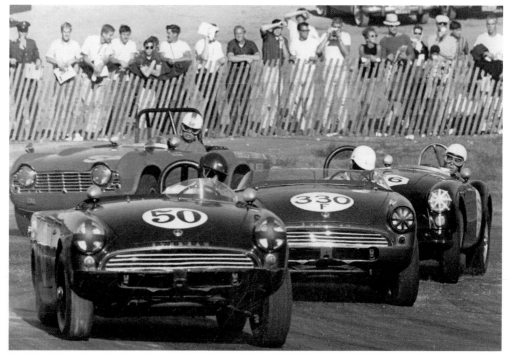

A pair of Sunbeam Alpines leads an MG and a Triumph during a race in the early 1960s. The only thing between the cars and fans is slat wood fence. (Courtesy Mazda Raceway.)

THE MACHINES

It seems like drivers have a different idea of which way the track goes during this 1960s Formula Vee race. Formula Vee cars of that era ran with a lot of stock VW components, with a 40-horsepower engine, stock transmission, suspension, wheels, and more. If a racer needed spare parts, he could go to his local auto parts junkyard and find a great deal of what he needed. (Courtesy Mazda Raceway.)

A group of street legal sports cars lines up for a rolling start. In this shot are MGs, Triumphs, and a single Corvette bringing up the rear. Mid-pack, a very rare Porsche 904 can be seen. This is probably a local car club out for a weekend event. (Courtesy Mazda Raceway.)

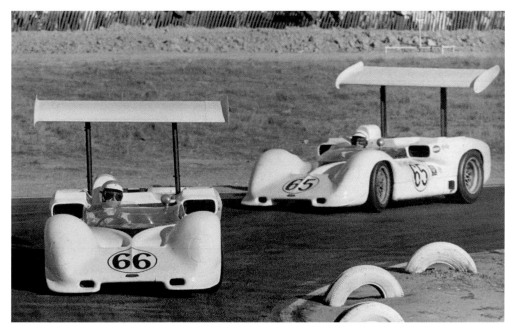

Pictured are the Chaparrals of Jim Hall (No. 66) and Phil Hill (No. 65) during the 1966 Can-Am race. The cars certainly brought the world of aerodynamics into the world of auto racing. Hill would win the race. (Courtesy Mazda Raceway.)

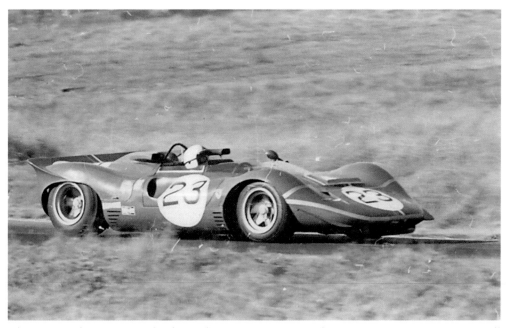

Chris Amon from New Zealand ran this Ferrari P4-350 in the 1967 Can-Am at Laguna. Well down on power compared to the American V-8 in all the other cars, Amon qualified in 13th place, kept out of trouble, and was rewarded with a fifth-place finish. This Ferrari was basically an endurance racer with the roof cut off. (Courtesy Mazda Raceway.)

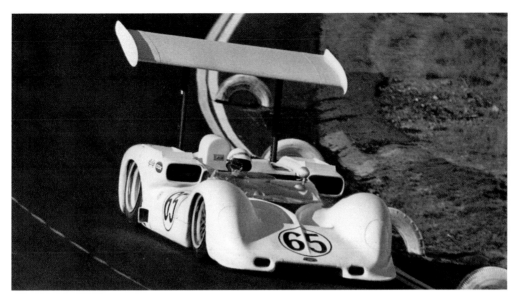

Phil Hill, driving his Chaparral 2E, works his way around turn two during the 1966 Can-Am race. Hill became the first American to win the World Drivers Championship in 1961. The Chaparral was the first race car to really take advantage of aerodynamic devices. The wing would lay flat on straights and dip forward in the corners, which would add pressure to the rear of the car for better handling. (Courtesy Bill Hewitt.)

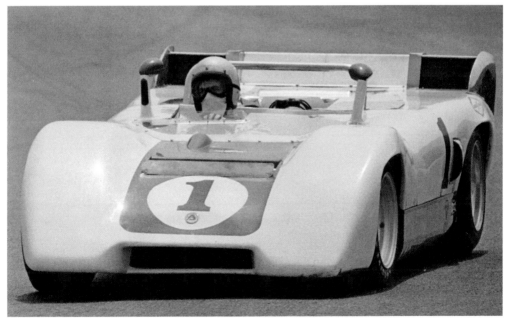

The Caldwell D7 was another idea that didn't work very well. It was driven at Laguna in 1967 by Sam Posey (and in 1968 by Brett Lunger). Try as they might, the team could never make the car a top contender. Posey, who funded the project, still owns the only surviving Caldwell. (Courtesy Mazda Raceway.)

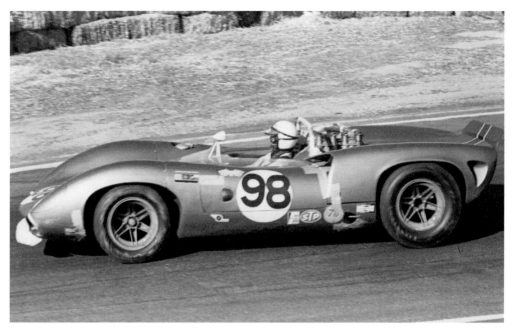

Parnelli Jones drives his Lola T70 during the 1966 Can-Am race here. P. J. qualified in 21st place, and in the first heat, he dropped out just after the start. But then in the second heat of the day, P. J. came on strong, passed everyone, and took the win. (Courtesy Mazda Raceway.)

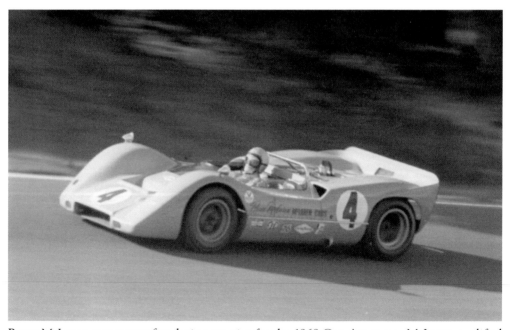

Bruce McLaren enters turn five during practice for the 1968 Can-Am event. McLaren qualified on pole position, but during the rain-soaked race, he finished in fifth place. McLaren cars won the series title every year from 1967 to 1971, with McLaren winning the drivers title in 1967 and 1969. McLaren race cars continue to win races into the 21st century. (Courtesy Mazda Raceway.)

THE MACHINES

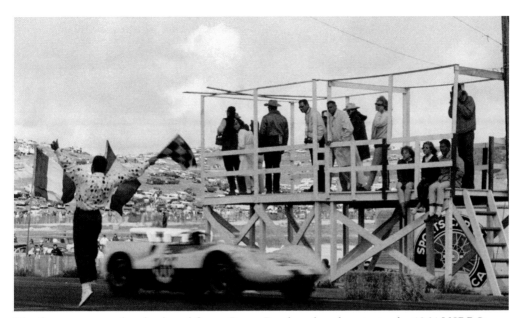

The flagman waves the checkered flag as Roger Penske takes the win in the 1964 USRRC race in his Chaparral 2A-Chevy. Hall was one of the pioneers of race car innovation in the 1960s and 1970s. Track officials stand in a wooden structure just feet away from the action. (Courtesy Mazda Raceway.)

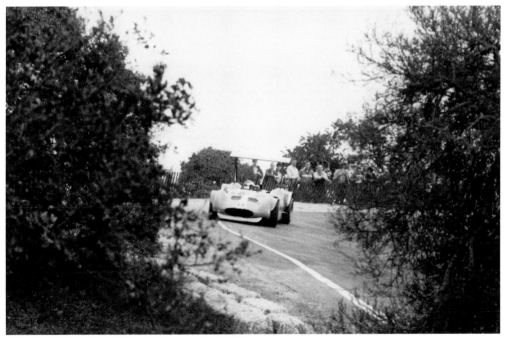

Don Jensen is shown driving his Burnett Chevrolet during the 1968 Can-Am race. Jensen qualified 16th and finished 13th in the race. Again notice the only thing between fans and the track is a wooden slat fence. (Courtesy Mazda Raceway.)

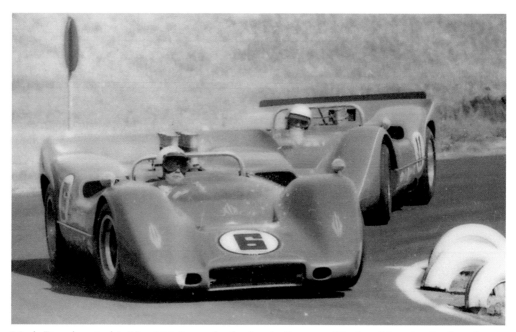

Mark Donahue in his No. 6 McLaren leads the similar car of Lothar Motschenbacher during the 1968 USRRC race. Donahue started the race from third and won the race. Motschenbacher started and finished the race in second place. (Courtesy Mazda Raceway.)

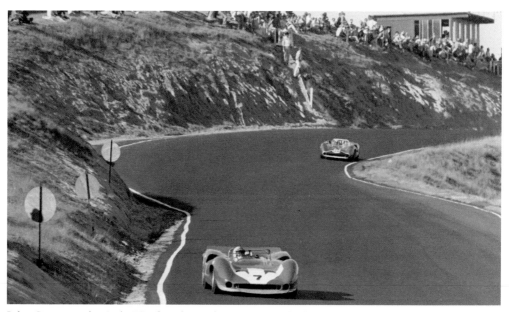

John Surtees in his Lola T70 flies down the main straight during the 1966 Can-Am race. Surtees was about as diverse a driver as there was. He was the only person to win both the World Drivers Championship and the World Motorcycle Championship. At this race, Surtees qualified in seventh place and finished fourth in the first heat and dropped out of the second. (Courtesy Mazda Raceway.)

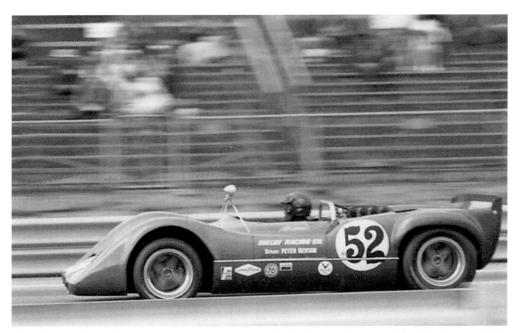

Peter Revson blasts down the front straight in his Shelby Racing McLaren Ford during the 1968 Can-Am race. Revson would start the race from fourth position but had a few problems in the race and finished 12th. (Courtesy Mazda Raceway.)

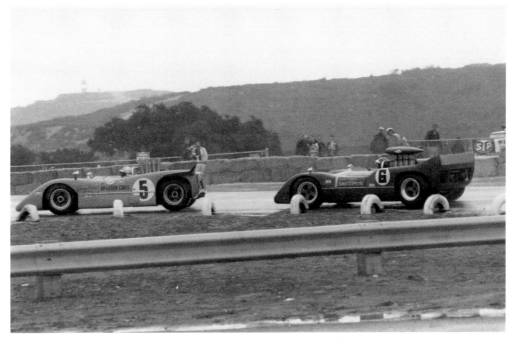

Denny Hulme in the No. 5 McLaren leads the No. 6 McLaren of Mark Donahue during the rain-soaked 1968 Can-Am race. It rained so hard that Donahue actually had to pull off the side of the track during the race to try to clear his foggy goggles. (Courtesy Mazda Raceway.)

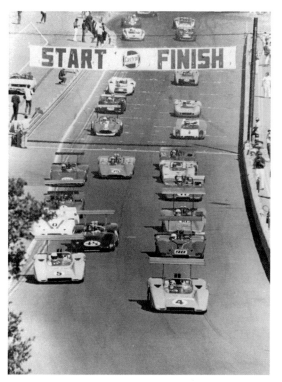

The start of the pace lap for the 1969 Can-Am race has Bruce McLaren's M8B Chevrolet (No. 4) leading away from the similar car of Denny Hulme. On the second row are the McLaren-Chevy of George Eaton (No. 98), Dan Gurney McLeagle's Chevrolet (No. 48), Chuck Parsons's Lola T-163 Chevy (No. 10), and Jo Siffert's Porsche 917 PA (No. 0). McLaren and Hulme finished the race first and second respectively. (Courtesy Dave Allen.)

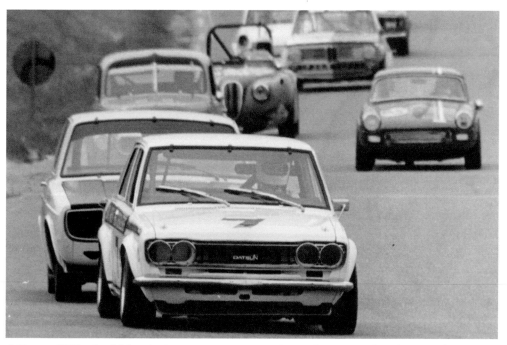

A Datsun 510 leads a Volvo during an amateur event. As can be seen in this photograph, amateur racing brings many different types of cars together on the track at the same time. BMWs and Morgans can also be seen here. (Courtesy Mazda Raceway.)

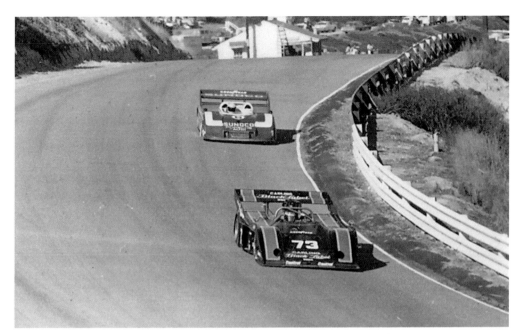

The McLaren factory team dropped out of the Can-Am series after the 1972 season. But in 1973, Englishman David Hobbs drove this privately run M20 Chevrolet. Here he works his way through turn one with Mark Donahue's Porsche in hot pursuit. (Courtesy Mazda Raceway.)

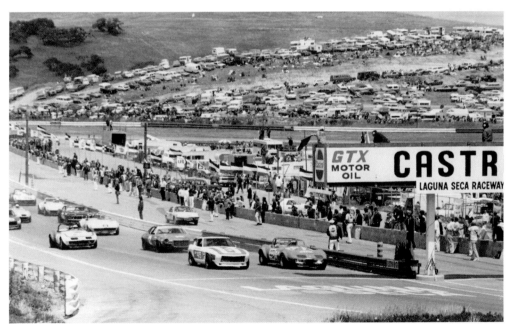

This shows the start of a Sports Car Club of America (SCCA) race in the mid-1970s. Corvettes, Camaros, and Mustangs battle it out. But the star was the Datsun 240Z (No. 45) of Walt Maas. Known as the "Giant Killer," Maas was famous for taking the fight to the larger engine cars and, most of the time, winning. (Courtesy Mazda Raceway.)

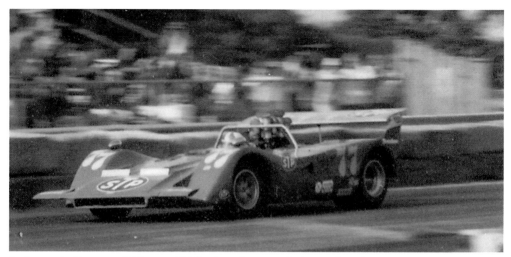

Is this a challenge to McLaren? Well, the 1970 March driven by Chris Amon was almost fast enough. At Laguna, he qualified the car in fifth position and raced the car hard to finish in fourth place. Unfortunately, the March effort never really got a fair chance to see what the car could do. They didn't even enter the series until the eighth race of the year. At the end of the 1970 season, the March factory effort came to a close. The car ran the next year in private hands but was never a threat for race wins. (Courtesy Mazda Raceway.)

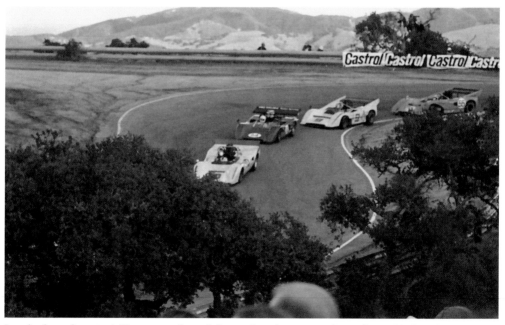

Just look at the view! Here are a few of the mid-pack runners from the 1972 Can-Am race. In front are the Lola T163 (No. 10) driven by Ron Grable, the McLaren M6B (No. 64) of Bob Peckham, the McLaren M8D (No. 9) of John Cordts, and Chuck Parsons's McLaren M8FP (No. 55). None of the drivers had what could be called a good weekend, with Peckham being the only one to finish, in 13th place. (Courtesy Chip Oetting.)

THE MACHINES

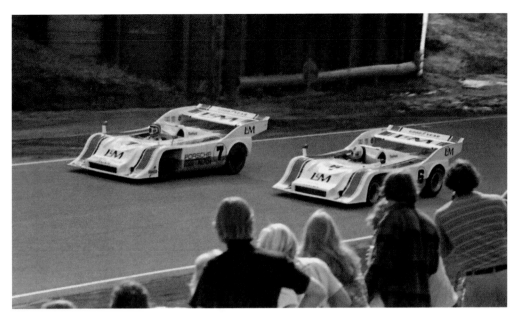

The first row for the 1972 Can-Am race is all Porsches; No. 6 is Mark Donohue and No. 7 is George Follmer. Both are in Penske Racing Porsche 917/10Ks. These beasts had almost 1,000 turbocharged horsepower available under the driver's right foot. There were three others in the race. Follmer won the race, and Donohue finished second. (Courtesy Chip Oetting.)

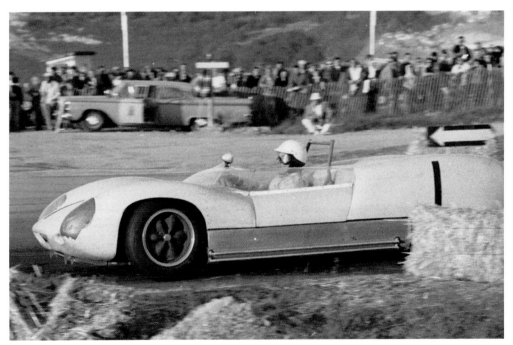

Stirling Moss drives through the turn nine hairpin in the early 1960s. Again, notice the safety measures of the day: hay bales on the inside but nothing on the outside. There is nothing between the racetrack and the course car in the background. (Courtesy Mazda Raceway.)

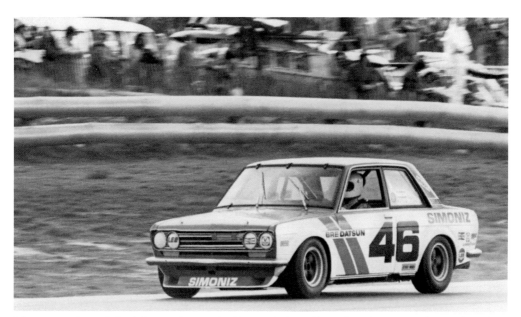

This image shows John Morton driving his Datsun 510 in the early-1970s Trans-Am under 2-liter class. Morton was very successful driving this car, and he went on to drive in the Can-Am and Indy cars and continued to drive sports cars into the 1990s. He still drives historic race cars today. (Courtesy Mazda Raceway.)

A mechanic crawls under the Lola T163 of Peter Revson prior to the 1969 Can-Am event. Revson qualified the car in third but blew up his motor during the race. Lola cars won the first series championship in 1966, but after that time, wins were few and far between as first McLaren, then Porsche, took the majority of series wins. (Courtesy Mazda Raceway.)

This is not someplace a driver wants to be. An unlucky Lotus driver spins in the middle of the Corkscrew. The first part of the corner is a completely blind left, and unless drivers pay attention to corner worker flags, this type of situation could become a bad accident. (Courtesy Mazda Raceway.)

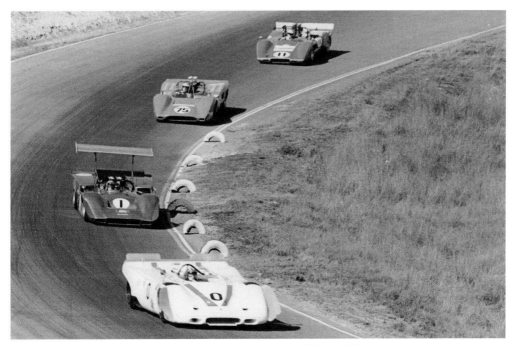

Jo Siffert's Porsche 917PA leads Mario Andretti's Lola M6B Ford (No. 1) and others during the 1969 Can-Am event. Andretti's career went so well that turn two at Laguna is named after him, the Andretti Hairpin. (Courtesy of Mazda Raceway.)

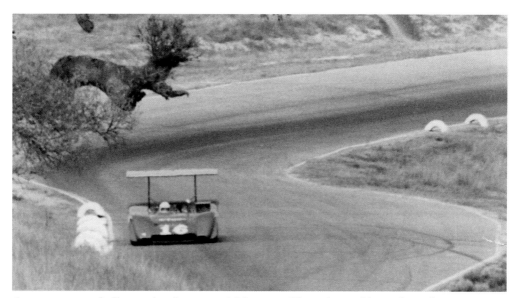

Attempting to challenge the dominant McLarens, Chris Amon blasts through turn two in his Ferrari 612 in 1969. Amon qualified the big Italian car in third position. But during the Sunday morning warm up, the car blew its engine. Amon was then given use of the spare factory McLaren for the race. The race didn't go Amon's way, and he dropped out with gear problems near the end of the race. (Courtesy Mazda Raceway.)

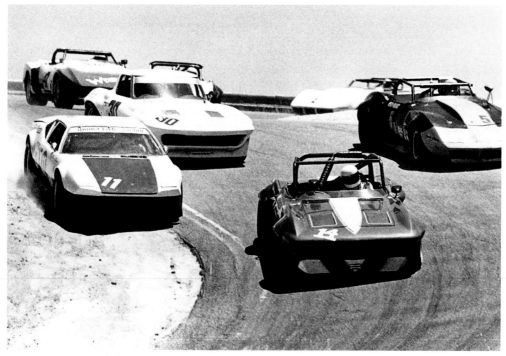

Corvettes surround the driver of a lonely Pantera during an SCCA event in the early 1970s. (Courtesy Mazda Raceway.)

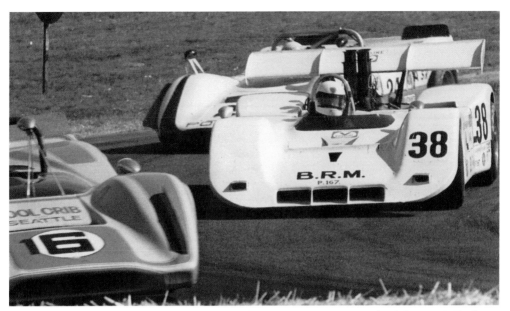

Brian Redman works through the field during the 1971 Can-Am race in his BRM P167. Redman qualified an impressive sixth and drove hard during the race to finish fourth. Another versatile driver, Redman would win several Formula 5000 titles over the coming years. (Courtesy Mazda Raceway.)

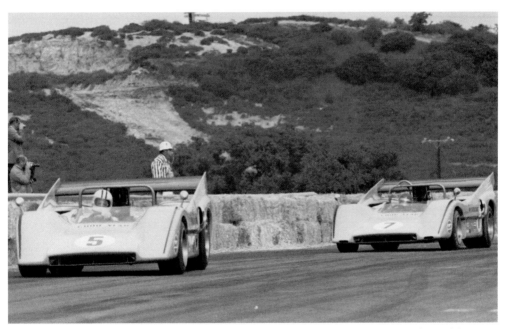

Denny Hulme powers out of turn nine ahead of Peter Gethin during the opening laps of the 1970 Can-Am race. Both are driving McLaren M8D Chevrolets. Hulme qualified on pole position and won the race. Gethin started second but dropped out of the race with mechanical problems. (Courtesy Mazda Raceway.)

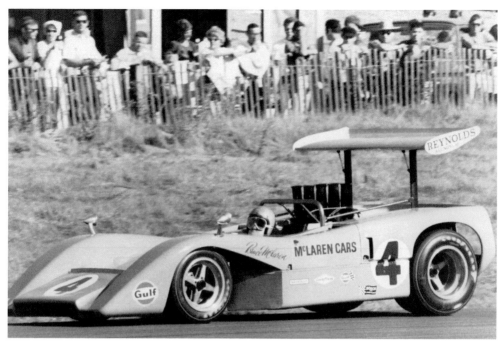

Bruce McLaren drives his McLaren M8B to victory in the 1969 Can-Am race. As with most major race series that year, cars grew huge rear wings to help with aerodynamics. (Courtesy Mazda Raceway.)

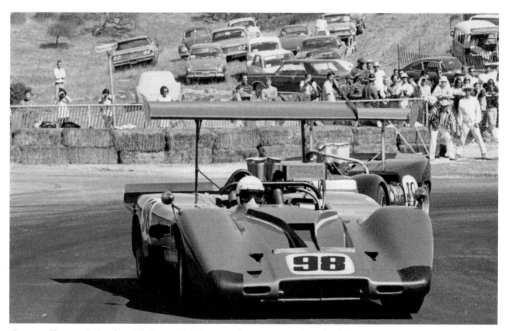

George Eaton slides his McLaren M12 out of turn nine ahead of Dan Gurney's McLeagle. Fans now have hay bails in front of wire fences to help with safety, but they still have a great view of the action. (Courtesy Mazda Raceway.)

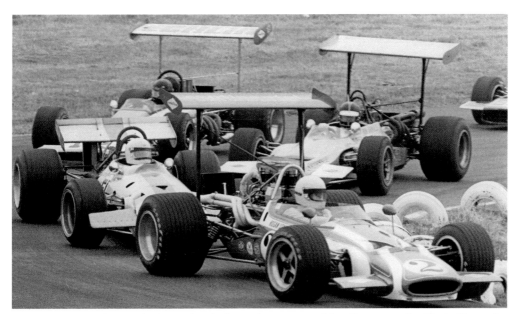

In 1969, a group of Formula A cars battle through turn nine. John Cannon in his Eagle Chevrolet (No. 2) leads the field. Huge, high wings were the norm that year. But serious problems with the struts holding the wings meant that after this year, the high wings would become illegal. (Courtesy Mazda Raceway.)

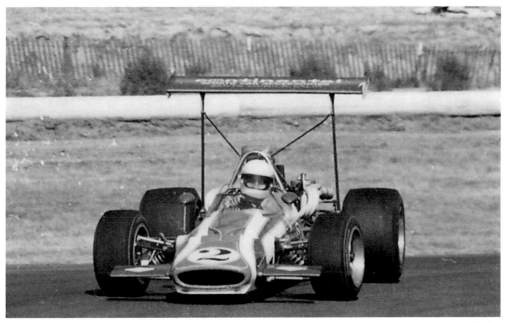

In another shot of John Cannon's 1969 Eagle Formula A car, one can see just how small the struts holding the wing were. Even with the added cross brasses, sometimes the wings just couldn't hold up under all the pressure. When a failure did occur, the car would become almost impossible to drive. (Courtesy Mazda Raceway.)

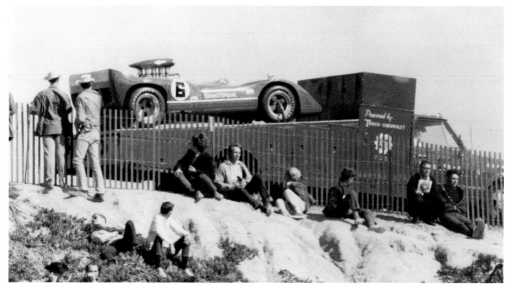

Mark Donahue's Can-Am McLaren arrives on its transporter for the 1968 race. Compare this simple set-up to the multi-million-dollar haulers used in the 21st century. Just about everything the team needed was contained in this simple truck. Back then, if a team needed something they didn't happen to have, chances are a competitor would lend it to them. (How times have changed.) (Courtesy Mazda Raceway.)

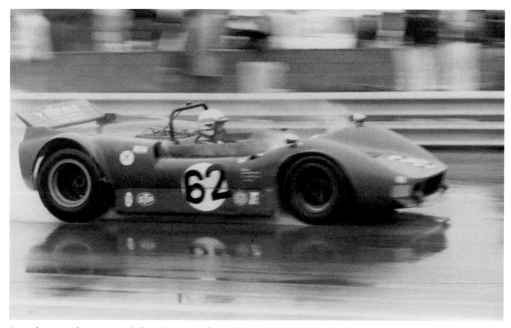

In a driving downpour, John Cannon drives his McLaren M1B Chevrolet to victory in the 1968 Can-Am race. With a special set of Firestone tires and hand-cut slits in his goggles, Cannon simply dominated the race. In fact, he was so dominant that he won the race by a full lap. The victory was worth $20,000. (Courtesy Tom Mountgomery.)

THE MACHINES

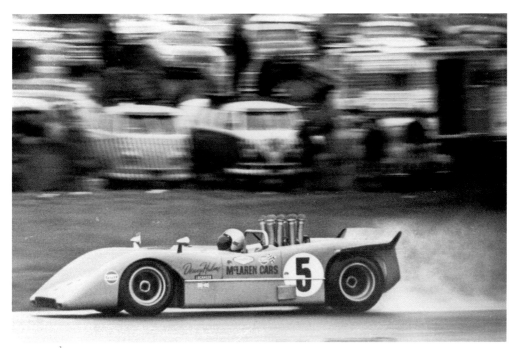

Denny Hulme splashes his way around Laguna in his McLaren during the 1968 rain-soaked Can-Am race. (Courtesy Mazda Raceway.)

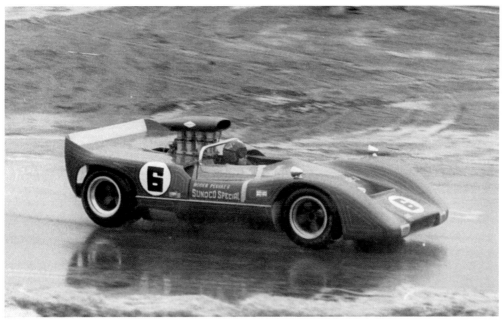

Mark Donahue tiptoes his way around the wet track during the 1968 Can-Am race. Donahue qualified fifth, and after having to stop on the track during the race to clear his driving goggles, he went on to finish in eighth place. Donahue is driving a McLaren M6B Chevrolet for Roger Penske. (Courtesy Mazda Raceway.)

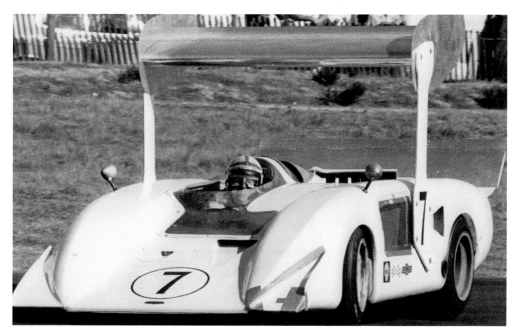

Pictured is the "white whale" of 1969. John Surtess is at the wheel of the Chaparral 2H. This is the only race in which the huge wing was used. Yes, it looks weird, and no, it didn't work. Surtess qualified 10th, but the engine broke on the pace lap. (Courtesy Dave Allen.)

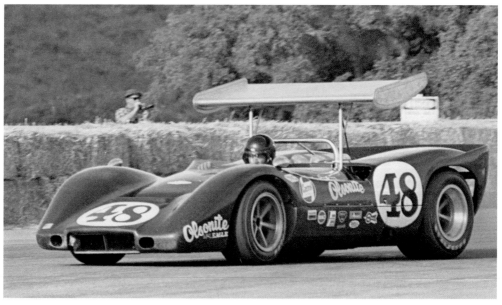

American Dan Gurney pilots his McLeagle around turn nine during the 1969 Can-Am race. Trying a bit of a different approach to the use of a high wing, Gurney ran his mounted just about the middle of the car instead of the extreme rear as with most others. Gurney qualified a solid fourth, but engine problems saw him drop out of the race after only 24 laps. (Courtesy Mazda Raceway.)

THE MACHINES

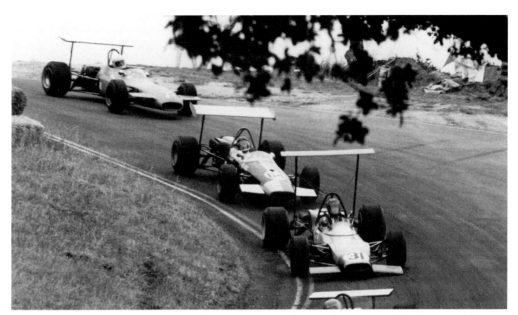

In the late 1960s, wings were everywhere. A group of Formula B cars works their way through the Corkscrew. Drivers and teams tried several different sizes and shapes, all trying to find the magic balance allowing the car to corner quickly but still be fast on the straights. (Courtesy Mazda Raceway.)

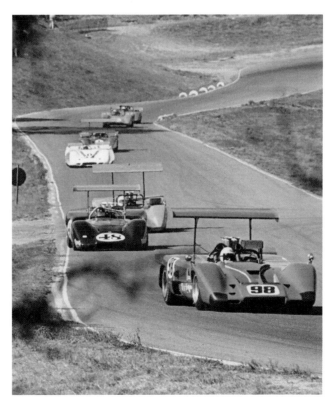

A group of Can-Am cars works through turn four in 1969. Lurking in the background is Jo Siffert's white Porsche. Although the car didn't win a race that year, Porsche was laying the groundwork for a series of cars that would bring the sports car world to its knees. (Courtesy Mazda Raceway.)

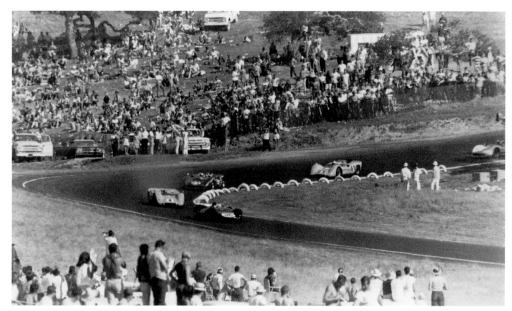

On the opening lap of the 1967 Can-Am race, Dan Gurney's Lola T70 leads the way. Behind Gurney are Bruce McLaren, Parnelli Jones, Denny Hulme, and Mike Spence's McLaren. Gurney pushed the McLarens hard all season long, but poor reliability meant he didn't finish any of the Can-Am series races during the year. (Courtesy Mazda Raceway.)

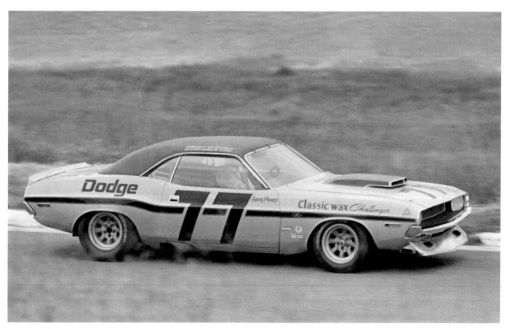

Part of the Trans-Am series in the early 1970s, Sam Posey pilots his Dodge Challenger at Laguna. The Trans-Am series brought together all the major U.S. auto manufacturers and was given the unofficial title "Pony Wars." Detroit brought their best muscle cars and ran door handle to door handle. (Courtesy Mazda Raceway.)

THE MACHINES

Denny Hulme takes a look in his mirror to try to find the pursuing John Cannon during the 1968 Can-Am race. Hulme was leading at the time in his McLaren, but as with almost all drivers in the race, his goggles started to fog up and vision became a problem. Cannon had cut a few small slits in his goggles and blasted past everyone to win the race by one full lap. (Courtesy Mazda Raceway.)

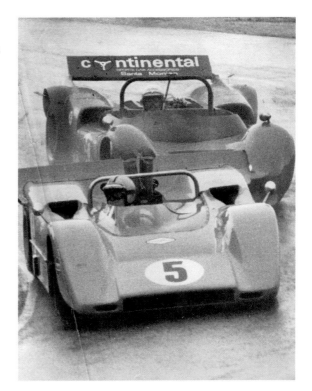

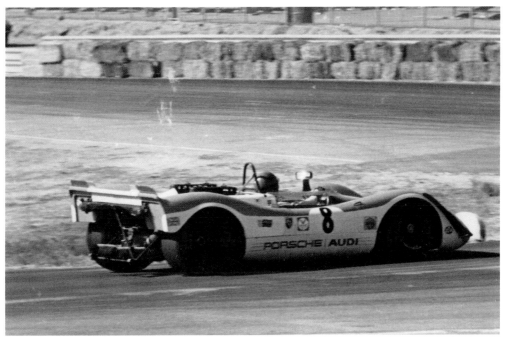

Tony Dean dives into turn nine in his Porsche 908 during the 1969 Can-Am race. Dean started the race from mid-pack and moved up to take a strong seventh-place finish. (Courtesy Mazda Raceway.)

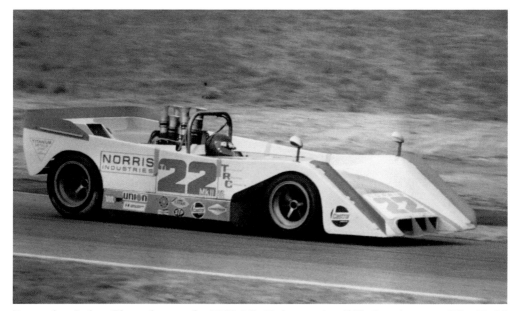

Pictured is Jackie Oliver driving the Ti22 Mk II during the 1970 Can-Am race. The Ti 22 differed from other cars of the time, using large amount of titanium instead of aluminum in its construction. Oliver would qualify fourth and finish second in the race. (Courtesy Mazda Raceway.)

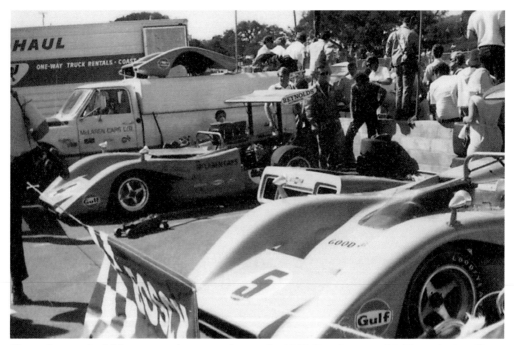

Shown here is the McLaren team's pit area during the 1969 Can-Am race. Unlike today's million-dollar setups, the team worked out of the back of a pickup and U-Haul truck, and spectators could get up close to the teams. (Courtesy Mazda Raceway.)

THE MACHINES

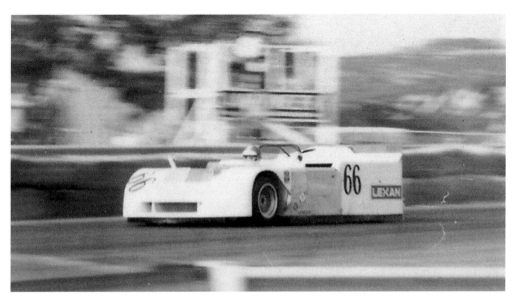

Vic Elford, driving the Chaparral 2J, blasts onto the main straight during practice for the Can Am race in 1970. Car owner Jim Hall was always at the forefront of technology, and the 2J was a perfect example. The car had an "extra" snowmobile engine at the back, which ran a pair of fans that then sucked the air out from under the car. This effect helped plant the car on the road and allowed for higher cornering speeds. (Courtesy Mazda Raceway.)

In this photograph, readers can see one of the two fans at the rear of the Chaparral 2J. The car's bodywork had an extension at the bottom that ran down to the track surface. These "skirts" help seal the bottom of the car, allowing the fans to suck the car to the ground. (Courtesy Mazda Raceway.)

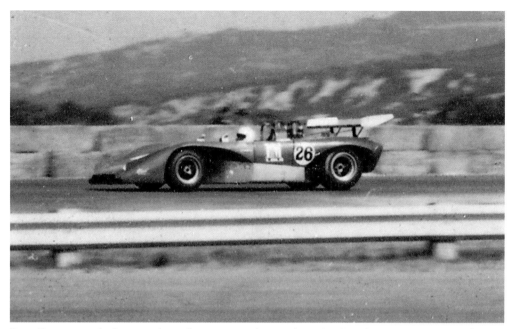

Peter Revson works his way through turn nine during the 1970 Can-Am race. Revson is driving a Lola T220 and qualified the car in third place. Revson pushed the whole race and finished a solid third. (Courtesy Mazda Raceway.)

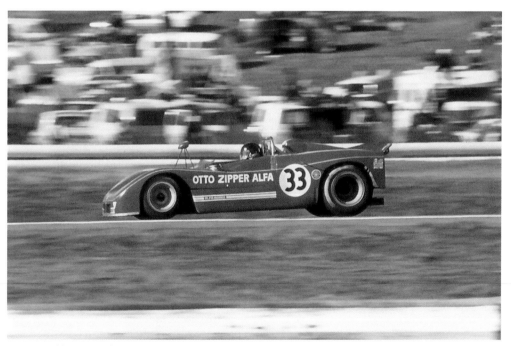

A nice addition to the 1973 Can-Am race was the Alfa Romeo T33/3 of Milt Minter. The little car may not have been as fast as the Porsche turbos, but Minter stayed out of trouble in the race and finished in a solid fifth place. (Courtesy Chip Oetting.)

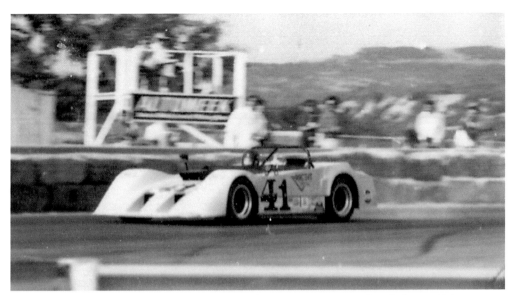

Now here is something really different. During the 1970 Can-Am weekend, the small Innovation Racing team brought their Mac's-it Special out for a run. Four 110-horsepower Rotax snowmobile motors powered the car, one at each wheel. The team could never make the car work right, and it was never anywhere near fast enough to compete. The car was withdrawn from the race and never seen again. (Courtesy Mazda Raceway.)

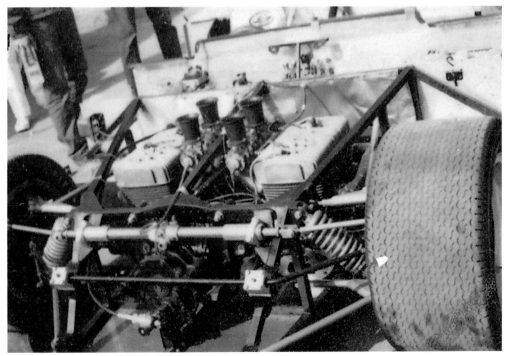

This is the Mac's-it Special without the front bodywork; visible are two of the car's four engines. Needless to say, the car sounded like nothing else ever has. (Courtesy Mazda Raceway.)

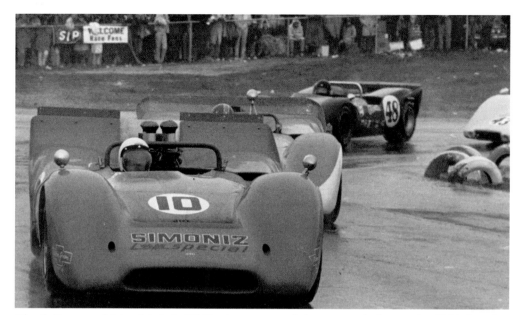

Chuck Parsons, driving his Lola T160, tiptoes around the wet track during the 1968 Can-Am race. Parsons qualified sixth for the race, but like many others during this race, he had problems and did not finish. Dan Gurney's McLeagle (No. 48) can be seen in the background. (Courtesy Mazda Raceway.)

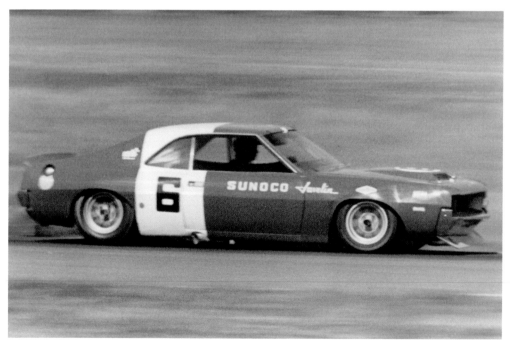

Mark Donahue is shown in another Roger Penske car. This time he is behind the wheel of an AMC Javelin in 1970. Against stiff competition from Ford, Chevrolet, and Dodge, Donahue went on to win that year's Trans-Am Championship. (Courtesy Mazda Raceway.)

THE MACHINES

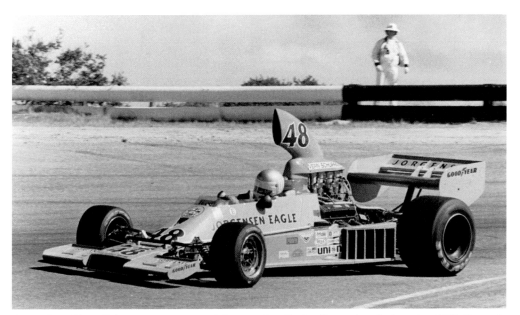

Australian Vern Schuppan is pictured driving his Eagle-Chevrolet during the 1975 Formula 5000 race. Schuppan's car was built and run by Dan Gurney's All American Racers in Southern California. Although it sometimes showed spurts of speed, the Eagle was no match for the Lola T332 in the series. (Courtesy Mazda Raceway.)

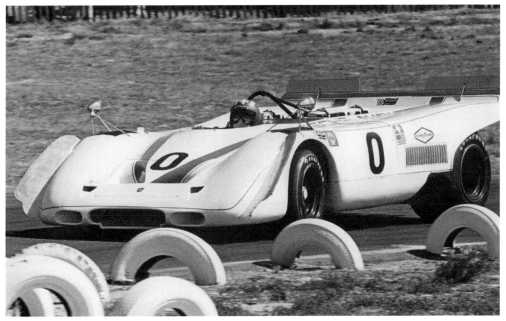

Jo Siffert, driving a Porsche 917PA, enters turn nine during the 1969 Can-Am race. Porsche wanted to run in the Can-Am series, brought their Le Mans car to the United States, and cut the roof off. The car was a bit underpowered but very reliable. Siffert qualified sixth and finished the race in fifth place. (Courtesy Mazda Raceway.)

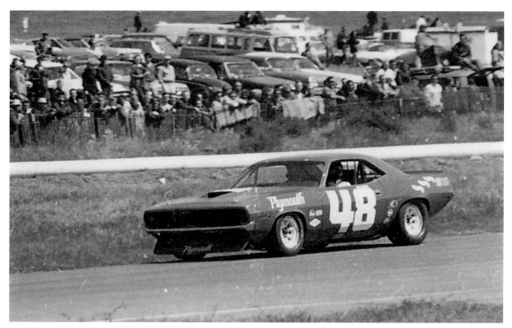

Dan Gurney, in his All American Racers Plymouth Barracuda, heads into turn nine during the 1970 Trans Am race. (Courtesy Mazda Raceway.)

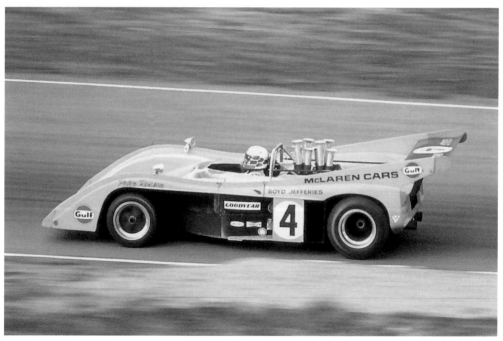

This is a McLaren M20 Chevrolet driven by Peter Revson during the 1972 Can-Am. A McLaren car had won every Can-Am race at Laguna from 1968 through 1971. But when the turbo Porsches arrived at the start of the year, McLaren knew they were in trouble. They dropped out of the series at the end of this year. (Courtesy Chip Oetting.)

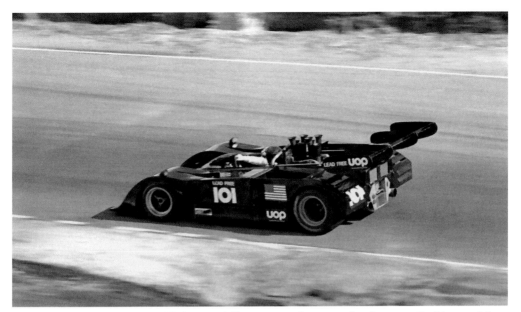

The Can-Am Series rules enabled many different manufacturers the chance to build cars of their own design. Here we see the UOP Shadow MK3 driven by Jackie Oliver in 1972. Unfortunately, after 25 laps, the Shadow developed an oil leak and didn't make it to the finish. (Courtesy Chip Oetting.)

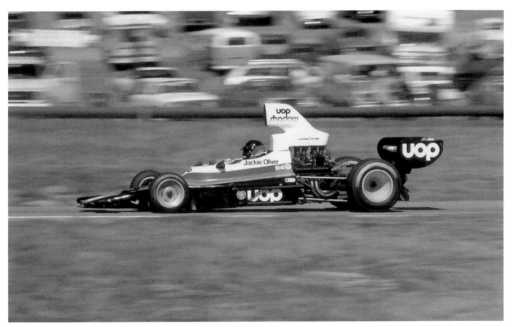

When the Can-Am Series was canceled after the 1974 season, the Formula 5000 Series took over as the headline act at Laguna. This is Jackie Oliver in the UOP Shadow DN6. Shadow bucked the trend, running their cars with Dodge engines at a time when Chevrolets powered the rest of the field. (Courtesy Chip Oetting.)

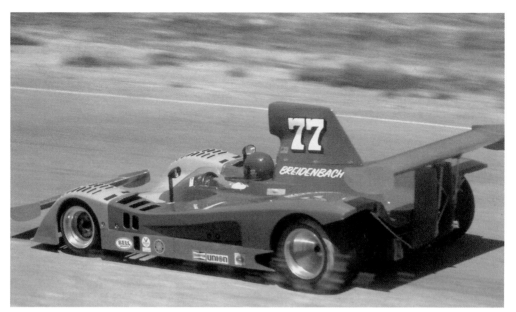

The Can-Am returns! Well, at least the name did. In 1977, the Sports Car Club of America decided to have all the Formula 5000 teams slap fenders on their F-5000 cars and start a new series. It lasted until the early 1980s. Here is Don Breidenbach in his Lola T332 Chevrolet, working his way around Laguna's turn seven. (Courtesy Chip Oetting.)

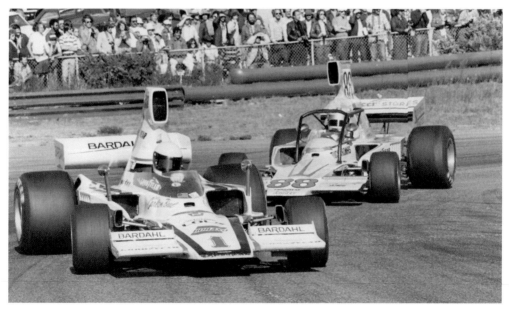

Brian Redman power slides his Lola T332 out of turn nine during the 1975 Formula 5000 race. Following Redman is the Lola of Tuck Tomas. Redman qualified and finished in third position. Redman won the series championship three straight years from 1974 to 1976. Formula 5000 cars were powered by small block (5-liter, 305–cubic inch) V-8 engines. Almost all cars ran Chevrolet power plants. (Courtesy Mazda Raceway.)

The Can-Am series stopped racing prior to the Laguna date. But the UOP Shadow team brought their two Can-Am cars and two of their Formula 1 cars and staged a "match" race for the fans. The Can-Am cars driven by Jackie Oliver and George Follmer were outmatched, and the Jean-Pierre Jarier F1 car seen here took the win. And yes, Jarier had some fun power sliding his car to the delight of the fans. (Courtesy Mazda Raceway.)

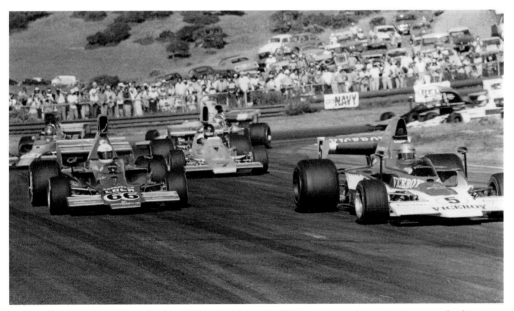

When the Can-Am series died in 1974, the Formula 5000 series took center stage as the big-time road racing series in the United States. With big-name drivers entering the series, large crowds flocked to Laguna. Here we see the No. 5 Lola driven by Mario Andretti bringing the field to the start. Alongside is the No. 66 car of Brian Redman. Behind Mario is another future World Driving Champ, James Hunt, in the No. 7 Eagle. (Courtesy Mazda Raceway.)

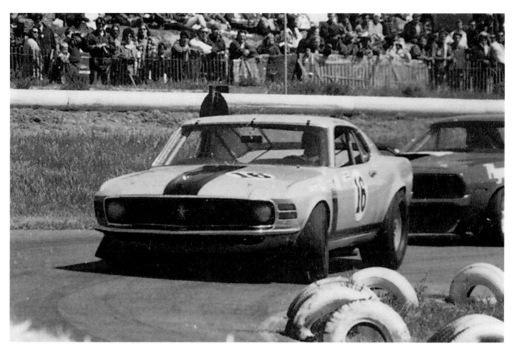

The Boss 302 Mustang driven by George Follmer turns into turn nine during the 1970 Trans Am race. (Courtesy Mazda Raceway.)

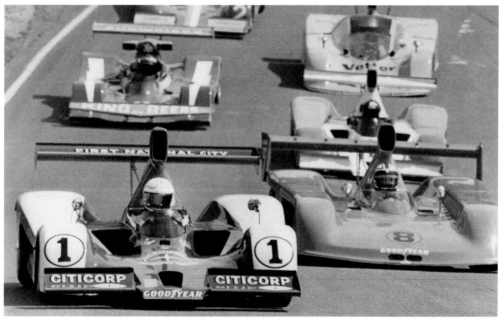

The start of the Can-Am in 1978 sees Alan Jones's Lola (No. 1) leading away from the Prophet of George Follmer (No. 8). The "new look" Can-Am series started in 1977, and the cars were basically full-bodied Formula 5000 cars. Australian Jones went on to win the F1 World Drivers Championship in 1980. (Courtesy Mazda Raceway.)

THE MACHINES

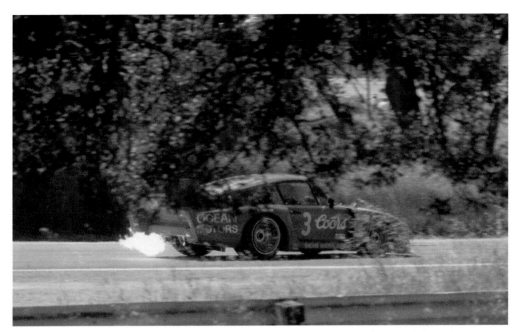

A Porsche 935 belches flames out of its exhaust during an International Motor Sports Association (IMSA) race in the 1970s. Unburnt fuel would collect in the system then ignite when the driver applied the throttle. It was spectacular stuff to watch. (Courtesy Butch Noble.)

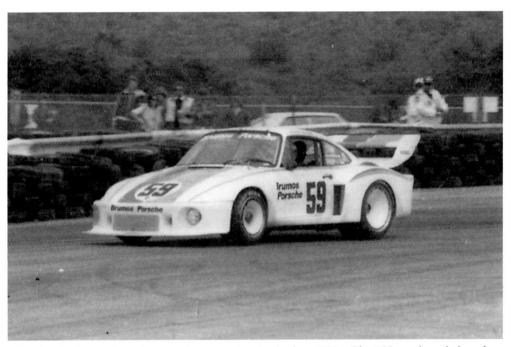

The Porsche 935 of Peter Gregg exits turn nine in the late 1970s. The 935 was loosely based on the company's 911 street car and came with a twin turbocharged six-cylinder engine that could produce massive amounts of power but was tricky to handle. (Courtesy Mazda Raceway.)

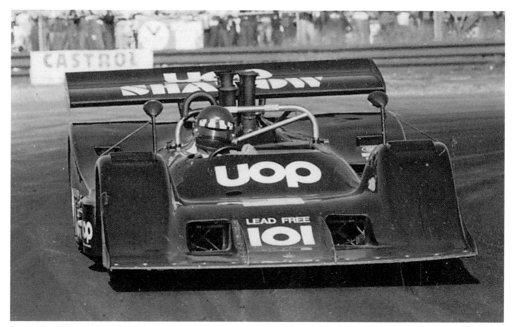

It was not quite a match for Donahue's Porsche, but the all-black UOP Shadow driven by Jackie Oliver sure looks good coming out of turn nine during the 1973 Can-Am race. Oliver would finish the race in second place. (Courtesy Mazda Raceway.)

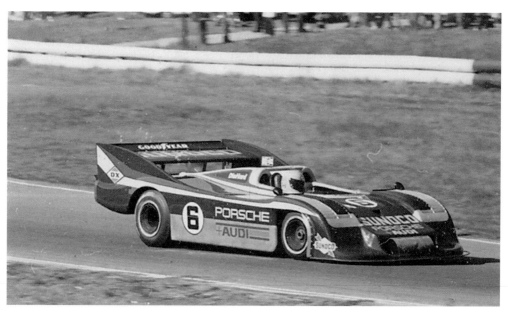

In 1973, Mark Donahue drove the Porsche 917/30 in the Can-Am series. Roger Penske owned the car. The big Porsche ran a 5.4-liter twin turbocharged engine that could develop in the neighborhood of 1,500 horsepower. Donahue started the race near the back as a result of practice problems, but in the race, he carved his way to the front and took the victory. (Courtesy Mazda Raceway.)

Winging their way through the bottom of the Corkscrew during the 1969 Can-Am race, the McLaren Chevrolet driven by Denny Hulme chases Mario Andretti's McLaren Ford. Hulme would finish second, Andretti fourth. (Courtesy Mazda Raceway.)

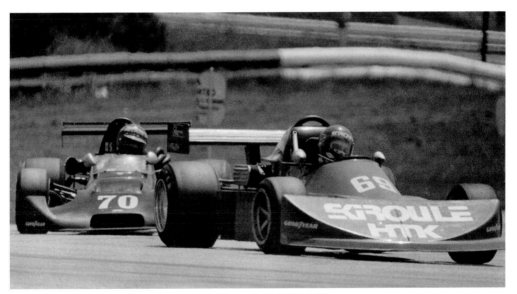

One of the all-time greats is shown here: Canadian Gilles Villeneuve driving his March Formula Atlantic (No. 69) in the mid-1970s. Villeneuve would become one of the great Formula 1 drivers of his era, driving for the Ferrari team. His no-quit attitude made him a fan favorite around the world. Unfortunately, during practice for the Grand Prix of Belgium in 1982, he was involved in an accident that claimed his life. Following Villeneuve in this photograph is Elliott Forbes Robinson (No. 70). (Courtesy Mazda Raceway.)

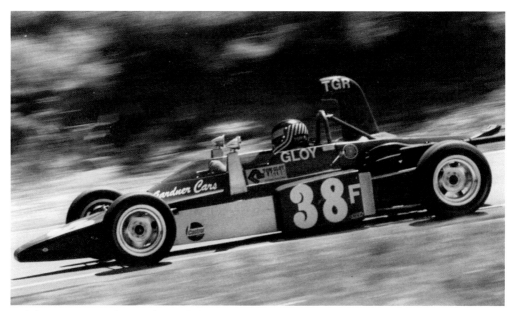

Californian Tom Gloy is shown behind the wheel of his Formula Ford in the 1970s. Gloy went on to have a very successful career, winning a few Formula Atlantic championships and Trans-Am championships (with a team he owned), and he ran in the Indy 500. (Courtesy Mazda Raceway.)

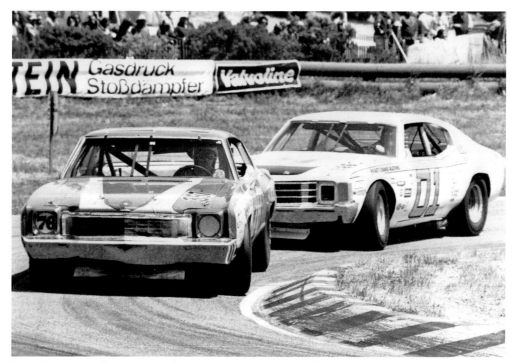

Even the National Association for Stock Car Auto Racing (NASCAR) has run at Laguna. Here a few "stockers" battle it out during the mid-1970s. (Courtesy Mazda Raceway.)

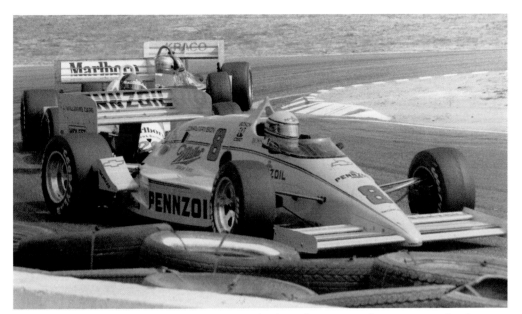

Rick Mears leads Emerson Fittipaldi and Michael Andretti onto the main straight during a CART race in the 1980s. Mears went on to win the Indy 500 four times. Fittipaldi not only won Indy but also the F1 World Driver Championship two times. Andretti won dozens of races and the CART title in 1991 and went on to own an Indy car team. (Courtesy Mazda Raceway.)

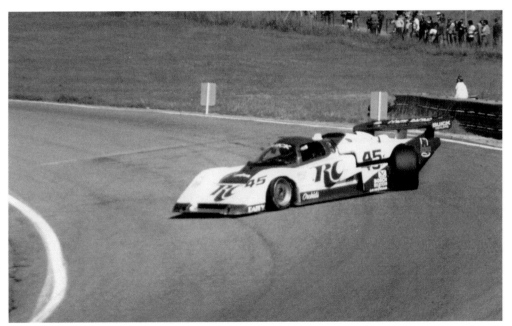

In 1986, John Paul Jr., driving this March Buick, had the center of his left rear wheel break. Right after this photograph was taken, the car nearly flipped over as the broken wheel worked its way under the car. Paul ended up crashing into the guard but walked away from the accident. (Courtesy Butch Noble.)

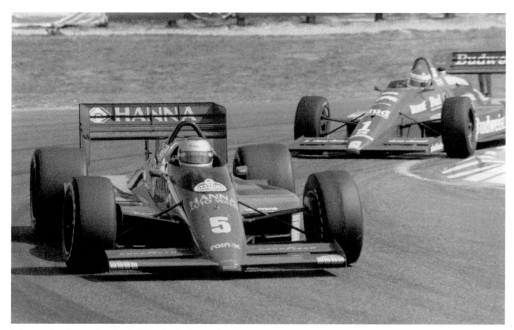

Mario Andretti leads Bobby Rahal in this late-1980s CART race. Andretti is one of the most recognized names in motor racing history. His list of accomplishments includes an Indy 500 win, a Daytona 500 win, and the 1979 Worlds Drivers Championship. (Courtesy Mazda Raceway.)

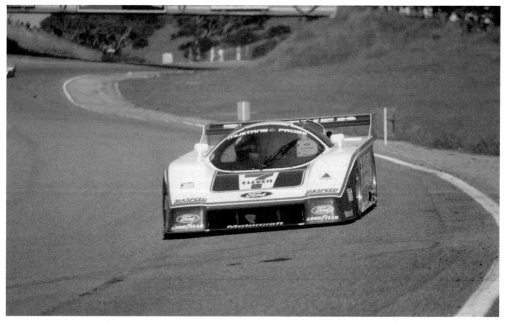

German Klaus Ludwig, driving a Ford Probe GTP car, enters turn eight during the 1986 IMSA race. Ludwig was one of the most successful sports car drivers of the era. He won the 24 Hours of Le Mans several times as well as various championships around the world. (Courtesy Butch Noble.)

Indy cars come to Laguna. The CART series made its first visit to Laguna Seca during the 1983 season. Teo Fabi, driving his March 83C, dominated the weekend and walked away with the victory. CART would continue to run events at the track well into the 21st century. (Courtesy Mazda Raceway.)

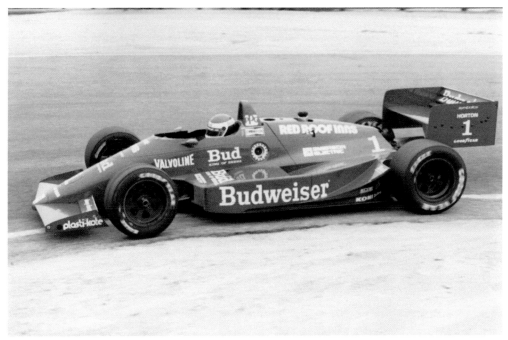

Bobby Rahal is shown entering the Corkscrew during a late-1980s CART event. Rahal won several CART races at Laguna and had success in other series over the years. He was so successful that one of the track's straights is now named after him. (Courtesy Mazda Raceway.)

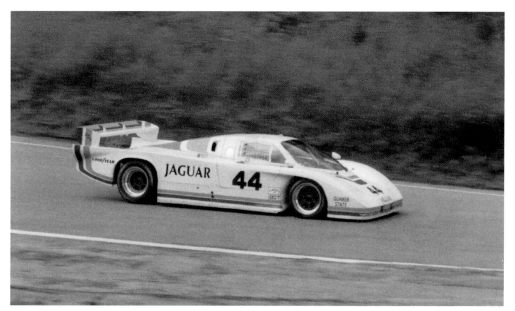

Group 44 Racing ran a team of Jaguars in the IMSA series in the 1980s. Bob Tullius ran the team, and the cars were fast enough to win several races. The team even made a few trips to the 24 Hours of Le Mans, bringing the British manufacturer back to the biggest sports car race in the world after an absence of almost 30 years. (Courtesy Butch Noble.)

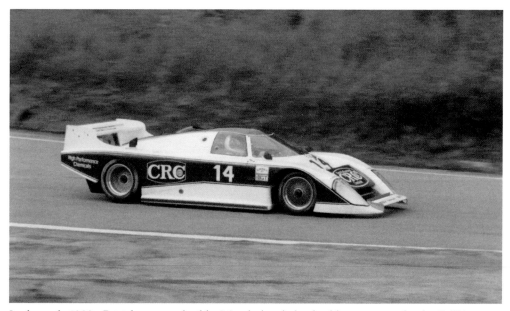

In the early 1980s, British race car builder March decided to build a sports car for the IMSA series. This is Al Holbert driving his example powered by a Chevrolet engine. The car would accept several other types of engines, including a turbocharged Porsche unit. (Courtesy Butch Noble.)

THE MACHINES

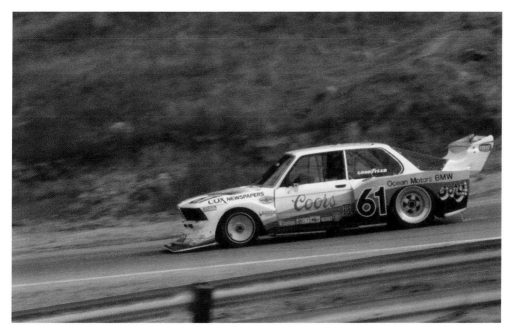

BMW took on Porsche during the 1970s in the Trans Am series. This is Jim Busby in 1979 driving a 320i Turbo. The cars were fast but not always reliable. Busby would go on to become a race team owner in the 1980s. (Courtesy Butch Noble.)

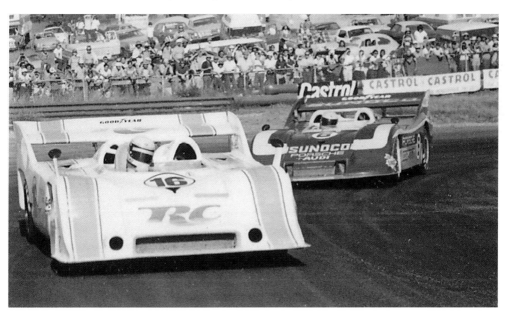

George Follmer, driving his Porsche 917/10K, leads Mark Donahue's Porsche 917/30KL during the 1973 Can Am race. Follmer did everything he could to keep Donahue behind, but after 44 laps, he had a turbocharger failure and dropped out of the race. Donahue and the big 917/30 won the race and the series title. Donahue's beast could be run with up to 1,500 horsepower. (Courtesy Mazda Raceway.)

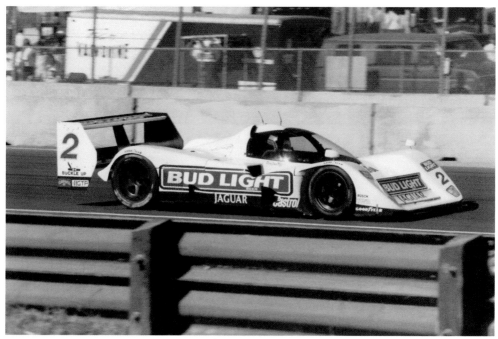

In 1992, Jaguar sent a new challenger to the United States–based IMSA series. The new Jaguar, the XJR-14, was powered by a 3.5-liter high-revving V-8 and driven by Davy Jones. The car was quick and won races, but 1992 marked the end of Jag's IMSA program. (Courtesy Butch Noble.)

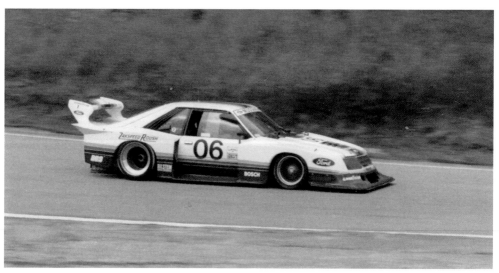

Before he went off to run a very successful NASCAR car team, Jack Roush ran Ford's road-racing programs. In the mid-1980s, Roush, along with German team Zakspeed, ran this Ford Mustang turbo in the IMSA series. The car ran with a small 4-cylinder engine, but with the addition of a turbocharger, the little motor pumped out big horsepower. (Courtesy Butch Noble.)

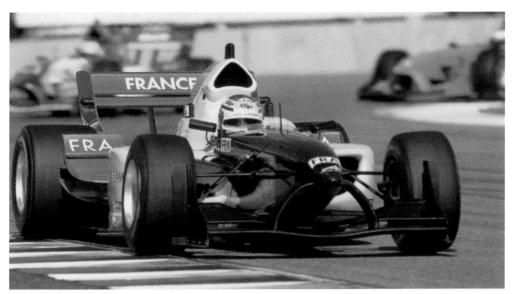

In 2006, the A1GP series held its only U.S. round at Laguna. Labeled as the "World Cup of Motorsports," this event featured national teams from around the world competing head-to-head in identical cars. This is team France, the team that would win the title. This was also the only race weekend in Laguna's long history where it actually snowed during the weekend. (Courtesy Butch Noble.)

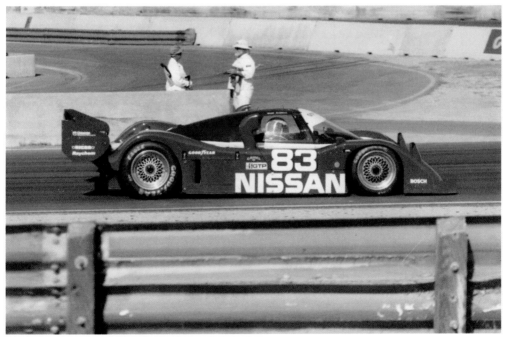

Nissan entered the IMSA GTP ranks in the 1980s. This is Geoff Brabham entering turn nine in 1992. Nissan went on to win multiple manufacturer and driver championships within a few years. (Courtesy Butch Noble.)

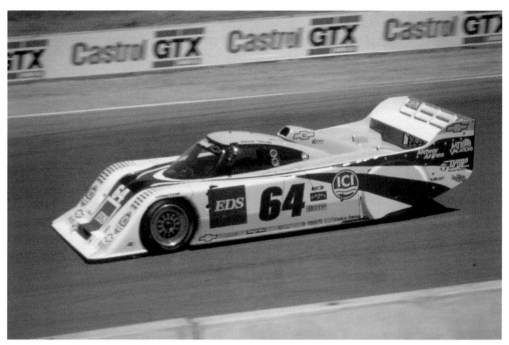

Wayne Taylor is pictured here at the wheel of the Intrepid GTP car in 1991. Powered by a Chevrolet motor, the Intrepid showed speed at times and won races. But racing against factory-backed teams from Nissan and Toyota was always an uphill battle. (Courtesy Butch Noble.)

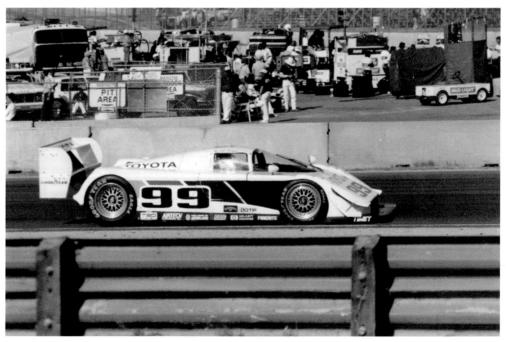

All American Racers built the Eagle-Toyota GTP cars in California. Here is Juan Fangio at the wheel during the 1992 IMSA event. (Courtesy Butch Noble.)

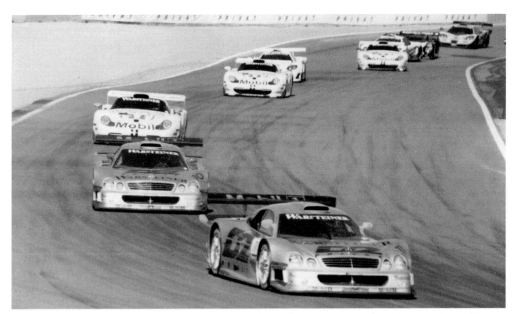

As something new, in 1997, the FIA GT Series brought European style to Laguna Seca. Here is the opening lap with two Mercedes Benz CLKs leading a mix of Porsches, McLarens, Panoz, and Lotus. The Mercedes won the race and the season-long championship. The series returned in 1998, and Mercedes won again. But high costs doomed the series, and it didn't return to Laguna and was cancelled soon after. (Courtesy Butch Noble.)

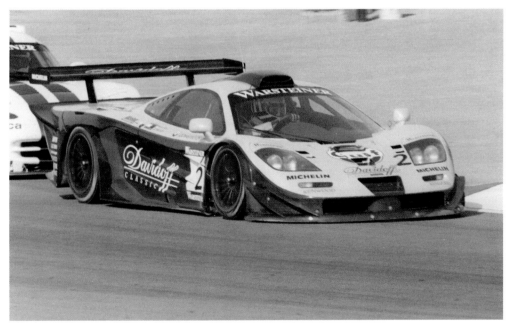

John Nielsen works through turn five during the 1997 FIA GT race. Nielsen is driving a McLaren F1 GTR powered by a 6.1-liter BMW V-12 engine. Nielsen was teamed with Thomas Bscher. The pair qualified 12th and finished the race in 10th place. (Courtesy Butch Noble.)

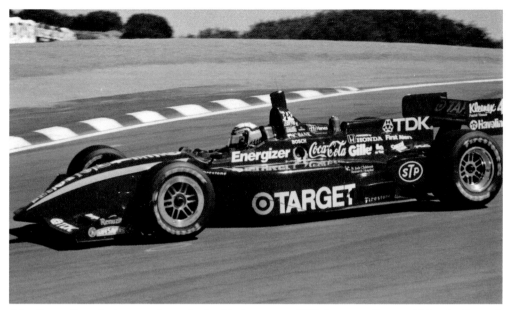

Alex Zanardi works his way through the Corkscrew in 1996 driving a Reynard Honda. Zanardi won the race with a last lap pass of Bryan Herta entering the Corkscrew that will never be forgotten. The move is simply known as "the pass." Zanardi won back-to-back Champ Car titles in 1997 and 1998. (Courtesy Butch Noble.)

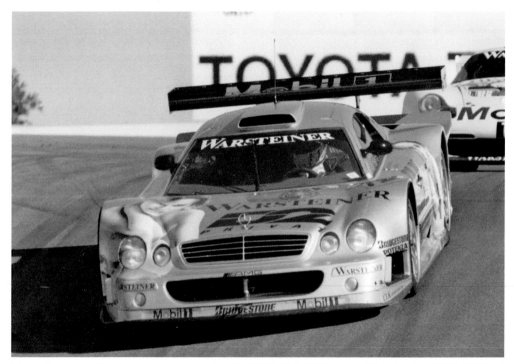

Mercedes entered a factory-run team in the 1997 FIA GT series. This is the CLK GTR of Alexander Wurz and Gregg Moore. (Courtesy Butch Noble.)

THE MACHINES

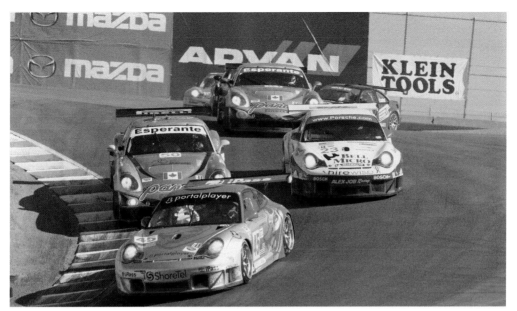

Over the years, Porsches have always been a part of Laguna Seca. Here we see the Flying Lizard Motorsports 911 GT3RSR (No. 45), driven by Johannes Van Overbeek, leading a group of GT2-class cars on the first lap of the American Le Mans Series race in 2006. (Courtesy Butch Noble.)

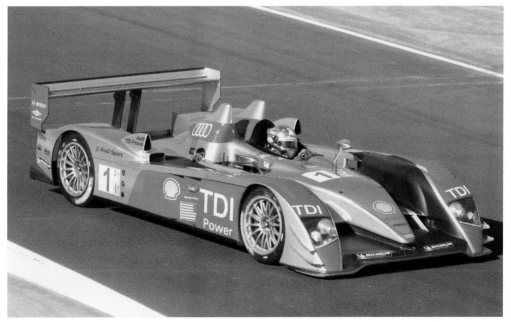

The diesel-powered Audi R10 driven by Rinaldo Capello/Allan McNish enters turn six. The duo drove the big turbocharged diesel V-12 engine car to the 2007 American Le Mans Series win at Laguna and crossed the finish line less than one second ahead of the second-place Porsche RS Spyder after four hours of racing. (Courtesy Butch Noble.)

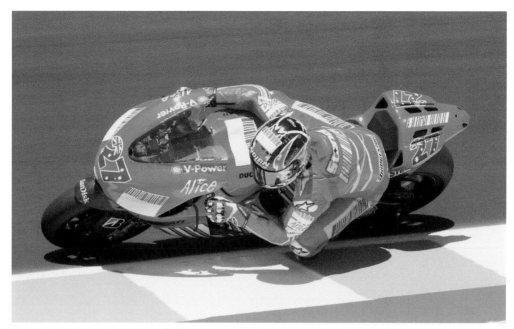

Australian Casey Stoner works his way around Rainey curve during the 2007 Red Bull U.S. MotoGP. Stoner, riding a Ducatti, won the event, which helped him to take the season-long World Championship title. (Courtesy Butch Noble.)

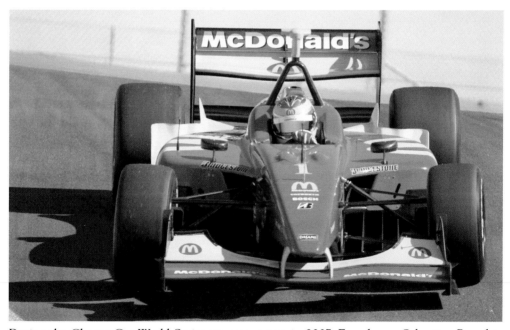

During the Champ Car World Series pre-season test in 2007, Frenchman Sebastian Bourdais broke the all-time track record at Laguna. Bourdais was driving for Hollywood film legend Paul Newman. At the end of the season, Bourdais claimed his fourth Champ Car title, then left the series for his dream to drive in the Formula 1 World Championship. (Courtesy Butch Noble.)

3

THE PEOPLE

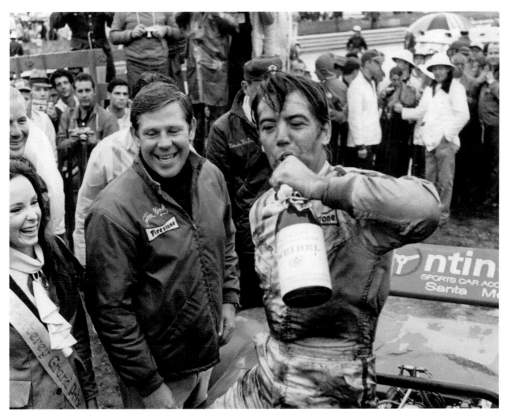

This is the taste of victory. After a hard day's work, John Cannon takes a drink of champagne following his win in the 1968 Can-Am race. Notice just how dirty Cannon's driving suit is. This day, Cannon washed away all the Can-Am's heavy hitters. (Courtesy Mazda Raceway.)

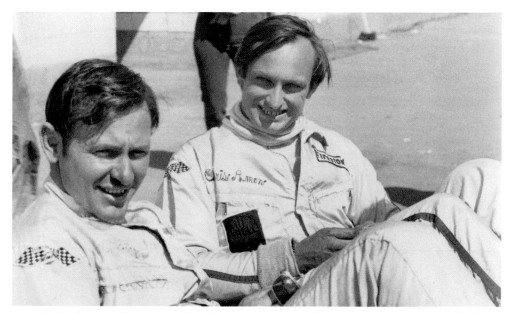

New Zealand was well represented in the Can-Am series. Here we see Bruce McLaren (left) and Chris Amon sharing a laugh together. McLaren is the father of the McLaren race car company. The manufacturer is still winning races in the 21st century. Unfortunately, Bruce McLaren was killed testing one of his cars in 1970. (Courtesy Mazda Raceway.)

Prior to the 1966 Can-Am race, Phil Hill (left) and Jim Hall discuss race strategy. Or could it be that Hill is trying to extend the range of a car's radio antenna? Maybe he's reading sheet music and practicing being the maestro of the local orchestra. Whatever the case may be, he won that day's race. (Courtesy Mazda Raceway.)

THE PEOPLE

England's Graham Hill loved Laguna. He said, "I've driven all over the world; nothing else is like Laguna Seca." Hill won several Formula 1 titles. His list of race wins includes the Monaco Grand Prix, the Indy 500, and the 24 Hours of Le Mans. He is still the only driver to win all three major races. Hill's son Damon would also become World Champion, winning the title in 1996. (Courtesy Mazda Raceway.)

Graham Hill speaks to one of his mechanics while sitting in his Cooper Monaco during the early 1960s. Hill would become one of the all-time great drivers, winning the World Drivers Championship, the Indy 500, and the 24 Hours of Le Mans. He then went on to become a team owner and constructor of Formula 1 cars in the 1970s. (Courtesy Mazda Raceway.)

Armed with not just massive driving skills, Mark Donahue brought along an engineering degree. Teamed with owner Roger Penske, Donahue won titles in Trans-Am and Can-Am. Behind the wheel of the brutally powerful Porsche 917/30, Donahue won the last big-bore Can-Am race at Laguna in 1973. Donahue was killed during practice for the Austrian Grand Prix in 1975. (Courtesy Mazda Raceway.)

Parnelli Jones was a racer's racer. He was at ease on every track in every car from a quarter-mile dirt oval to the twist of Laguna Seca. Driving one of owner Bud Moore's Boss Mustangs, Jones won the ultra-competitive 1970 SCCA Trans-Am. He also won the second heat of the 1966 Can-Am race at Laguna. (Courtesy Mazda Raceway.)

THE PEOPLE

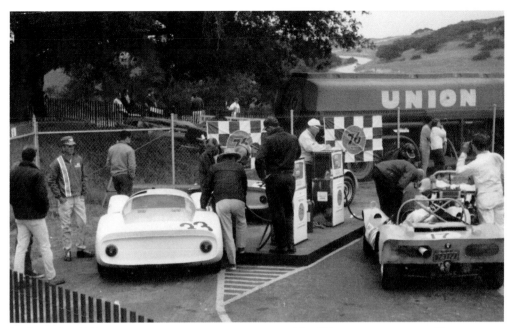

Back in the 1960s, putting gas in a race car was just like filling up a street car. Here are two Porsche 906s on the left with two sports racers on the right. Notice the car nearest on the right side has a license plate attached to the back. (Courtesy Mazda Raceway.)

Corner workers man their station in the late 1960s. In the background can be seen turns one and two and leading off toward turn three. When the track configuration changed in the late 1980s, turn two would become a left-hand hairpin turn. (Courtesy Mazda Raceway.)

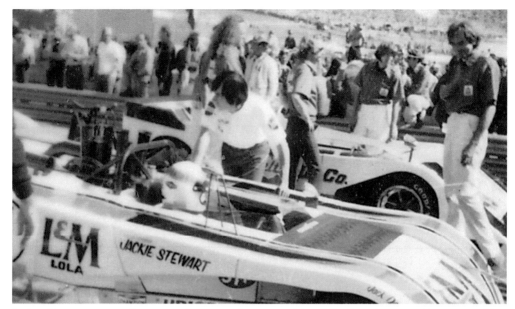

Jackie Stewart sits on the pre-grid prior to the start of the 1971 Can-Am race. Stewart and his Lola T260 did everything they could to bring down the McLaren domination that year, even winning a few races. Here at Laguna, he qualified fourth and finished second. In Europe this year, he won his second of three World Drivers titles. (Courtesy Mazda Raceway.)

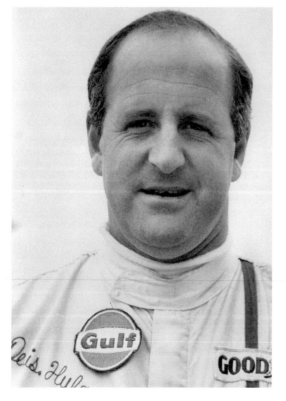

"The Bear," as New Zealand's Denny Hulme was known, was just that—a bear behind the wheel. He became part of the McLaren Can-Am team in 1968. He would win the race at Laguna in 1970 and took the series championship in 1968 and 1970. (Courtesy Mazda Raceway.)

THE PEOPLE

A driver stands by and watches after his car broke down as another car blasts past, entering the Corkscrew during the Formula 5000 race in 1975. You've got to love the sideburns. (Courtesy Mazda Raceway.)

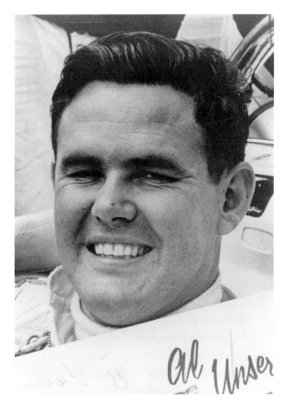

Al Unser drove in several Formula 5000 races at Laguna and even a few later Can-Am events. "Big Al" went on to become the second driver in history to win four Indy 500s. (Courtesy Mazda Raceway.)

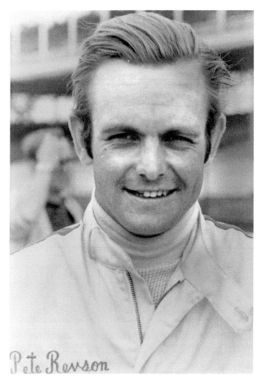

Peter Revson, driving a McLaren, won the Can-Am race at Laguna in 1971. He would also compete in the Indy 500 on five occasions and win two F1 races in 1973, also driving for McLaren. In 1970, Revson drove a Porsche with actor Steve McQueen to second place in the 12 Hours of Sebring. He was killed during practice for the 1974 South African Grand Prix. (Courtesy Mazda Raceway.)

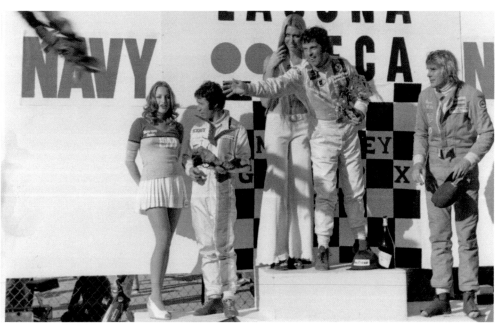

Pictured is the victory stand after the 1974 Formula 5000 race. In the middle, winner Brian Redman celebrates by throwing the victor's wreath. Mario Andretti (left) finished third, while on the right is James Hunt, the second-place finisher. Notice that Hunt has cut the toes out of his driving shoes. (Courtesy Mazda Raceway.)

THE PEOPLE

Another English star, Jimmy Clark drove his only race at Laguna in 1963 in a Lotus. He retired from that race after only 31 laps. But he would win the World Drivers Championship twice and the Indy 500 in 1965. (Courtesy Mazda Raceway.)

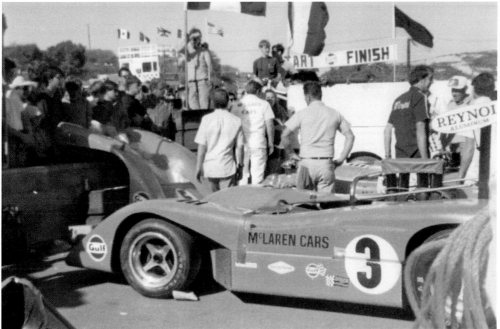

During the 1969 Can-Am race, fans gather around the McLaren team pit area. Things were sure different then. Notice the car is held in place by a small sand bag behind the front wheel, and the car's spare noise piece is hanging out into the crowd. (Courtesy Mazda Raceway.)

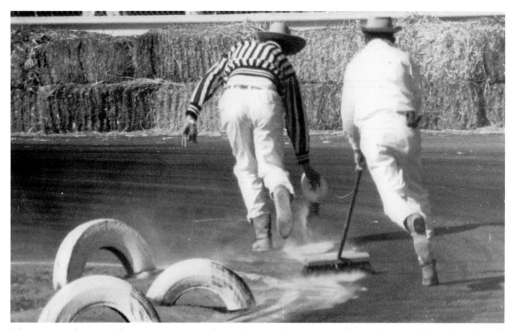

The unsung heroes of any race are seen here. A pair of corner workers clean up after a liquid spill during the 1960s. The first is putting down SpeedyDry, which will absorb oil, gas, or water after a mishap. (Courtesy Mazda Raceway.)

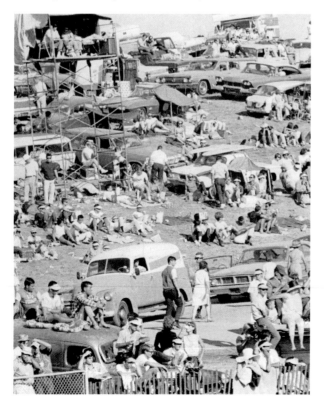

A huge crowd enjoys a sunny day during a race in the 1960s. Fans can be seen sitting on the top of their cars, pitching tents, and in cars with surfboards on top; a group has even built a tower out of construction scaffolding. (Courtesy Mazda Raceway.)

THE PEOPLE

Englishman David Hobbs drove many different cars at Laguna over the years, everything from Formula 5000, Can-Am, and IMSA BMWs. He was fast in all of them. Today Hobbs is part of the ESPN Formula broadcast team. (Courtesy Mazda Raceway.)

England's Stirling Moss won the 1960 and 1961 Pacific Grand Prix held at Laguna. In each race, he drove a Lotus 19. Over his career, Moss drove in over 525 races around the world. He won 16 Formula 1 Grand Prix races, most of them in British-built cars. Moss was injured at a racetrack in England in 1962, and when he recovered, he decided to retire from racing. (Courtesy Mazda Raceway.)

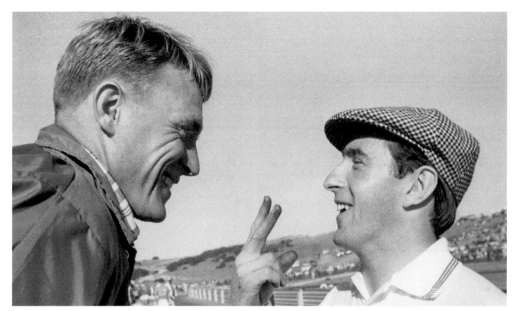

Two of the greats are pictured here. American Dan Gurney (left) and Scotsman Jackie Stewart share a laugh at Laguna in the 1960s. Gurney is the only American to win a Formula 1 race in a car he built. Stewart won three World Drivers Championships and would later own his own Formula 1 team. (Courtesy Mazda Raceway.)

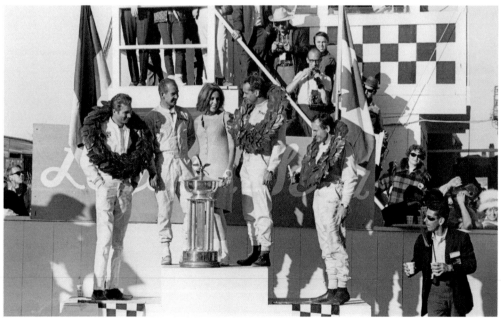

The victory stand after the 1966 Can-Am race is shown. From left to right are Jim Hall, Parnelli Jones, Miss Laguna Seca, Phil Hill, and Bruce McLaren. The race consisted of two heats. Hill won the first, Jones the second. The overall victory was taken by Hill, Hall was second, and McLaren third. (Courtesy Mazda Raceway.)

THE PEOPLE

While driving for the legendary Ferrari team in 1961, Phil Hill became the first American to win the Worlds Drivers Championship. He also won the 24 Hours of Le Mans on three occasions. Driving the high-winged Chaparral at Laguna Can-Am in 1966, Hill won the first of two heat races. With a second-place finish in the other heat race, Hill took the overall race victory. (Courtesy Mazda Raceway.)

In this picture from the late 1960s, Chuck Parsons sits on the grid discussing the upcoming race with a crew member. Unlike today's race cars, in the 1960s, drivers did not have radios to talk with their crews. They relied on working things out prior to the race. If the team needed to tell their driver something, they wrote it on a chalkboard and held it out over the pit wall for the driver to see. Hopefully he got the message. (Courtesy Mazda Raceway.)

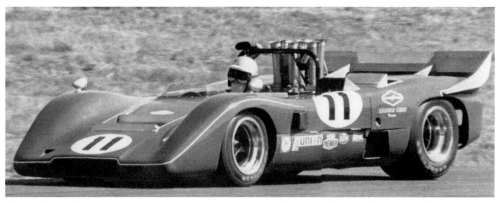

One of the all-time great race car driver names, Lothar Motschenbacher, drives his McLaren during the 1970 Can-Am race. Motschenbacher was one of the fan favorites, always willing to take a few seconds to talk. Here he qualified in 10th position but ran into mechanical problems and dropped out after 53 laps. (Courtesy Mazda Raceway.)

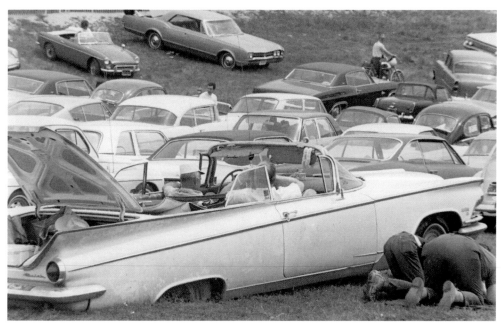

Here is a perfect example of what could happen at Laguna when the rains came. As a few people look over the situation, the driver and passenger don't really seem too concerned with being stuck. (Courtesy Mazda Raceway.)

THE PEOPLE

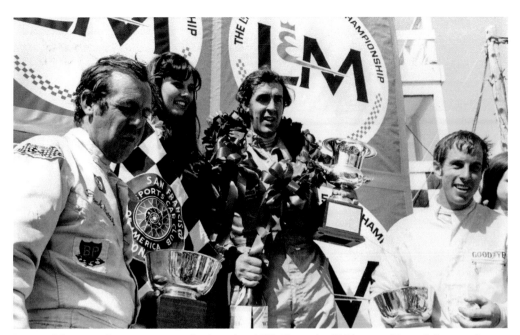

Pictured here is the victory stand after the 1971 Formula 5000 race. From left to right are second-place finisher Frank Matich, that year's Miss Laguna Seca, winner David Hobbs, and third-place finisher Brett Lunger. Hobbs would go on to win the series title that year. (Courtesy Mazda Raceway.)

Over the years, Al Holbert drove the wheels off of anything he drove. He was quiet out of the car, but once strapped in the driver's seat, he was all business. He became "Mister Porsche" in the 1980s, driving the manufacturer's 962 chassis to many victories, including the 24 Hours of Le Mans. (Courtesy Mazda Raceway.)

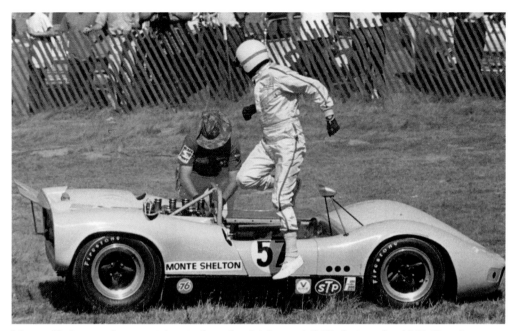

Monte Shelton makes a quick exit from his McLaren Mk1B during the 1969 Can-Am race. Shelton had qualified in the middle of the pack. But when the car caught on fire, Shelton had no choice but to abandon ship. (Courtesy Mazda Raceway.)

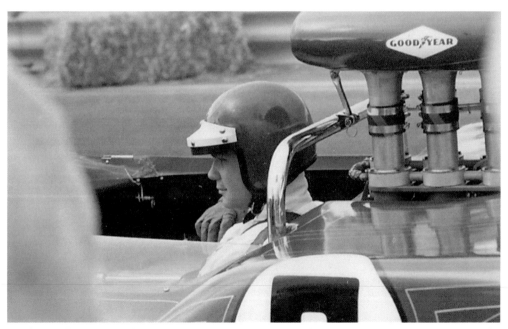

Mark Donahue waits in his McLaren prior to the start of the 1968 Can-Am race. Roger Penske owned Donahue's car, and the owner's attention to detail was in evidence way back then. Every piece was cleaned and polished between practice sessions, and not very many sports cars back then sported full bodywork pinstriping. Even Mark's helmet shines. (Courtesy Mazda Raceway.)

"King" Kenny Roberts works his way through the Corkscrew. Roberts won the World Motorcycle Championship and helped bring the sport bike craze to American soil. It's stronger today than ever, with Laguna's largest crowds coming to the MotoGP each year. (Courtesy Mazda Raceway.)

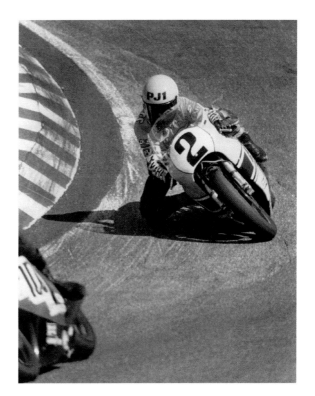

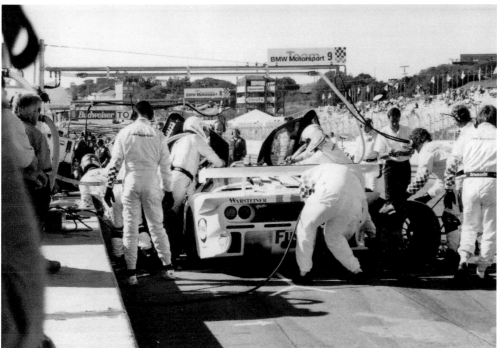

The factory McLaren Team services one of their cars during the 1997 FIA GT race. Notice that all the mechanics must wear fireproof safety suits. (Courtesy Butch Noble.)

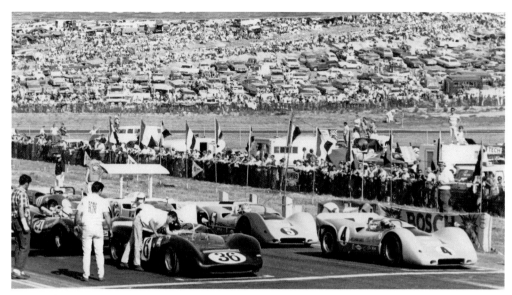

The field for the 1967 Can-Am race gets ready to take off. On pole position is Bruce McLaren's McLaren (No. 4). Also seen are the Lola driven by Dan Gurney (No. 36), the McLaren driven by Denny Hulme (No. 5), the Lola driven by Parnelli Jones (No. 21), and the high-winged Chaparral of Jim Hall. McLaren would win the race. Notice the huge crowd in the background. (Courtesy Mazda Raceway.)

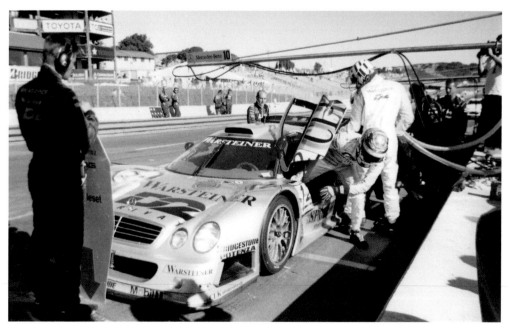

During the 1997 FIA GT race, Canadian Greg Moore jumps out of his Mercedes CLK and Austrian Alexander Wurz prepares to take the wheel. Moore was one of the rising stars of the Champ Car World Series, but in 1999, he was killed during a race at California Speedway in Fontana. (Courtesy Butch Noble.)

Mario Andretti—just the mention of the name means winning. And win he did. Andretti won the 1967 Daytona 500, the 1969 Indy 500, and the 1979 Worlds Drivers Championship. His career was so successful that Laguna named the track's turn two after him, the Andretti Hairpin. (Courtesy Mazda Raceway.)

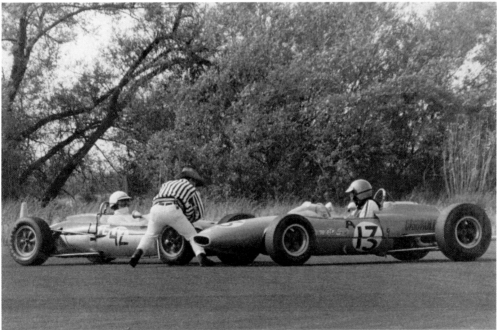

A course worker tries to help separate a couple of formula cars in the early 1960s. With safety being such a major topic in the 21st century, it's amazing to see that, just off the edge of the track, there are no barriers to keep cars from crashing into the trees. (Courtesy Mazda Raceway.)

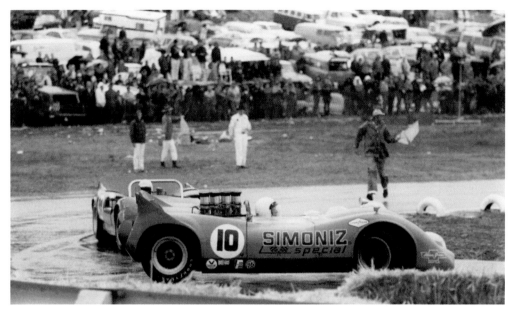

A corner worker runs out with the yellow flag to signal approaching cars after Chuck Parsons's spin in his Lola T160 during the rain-soaked Can-Am race in 1968. Notice the lack of any kind of protection the crowd in the background has. The only thing between fans and the track is a wire and wood fence. (Courtesy Mazda Raceway.)

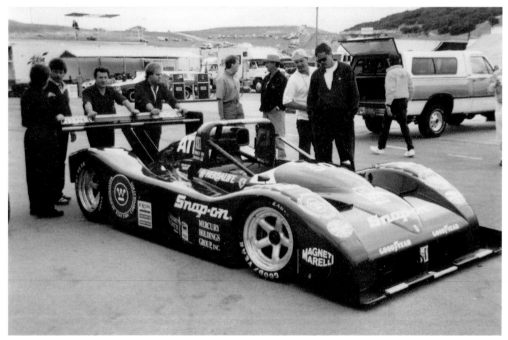

It is the return of the prancing horse. Team members push the new Ferrari 333SP through the pit area in 1994. This was the first purpose-built Ferrari prototype race car in more than 20 years. The fans looking the car over tell the story: the car was fantastic. (Courtesy Butch Noble.)

THE PEOPLE

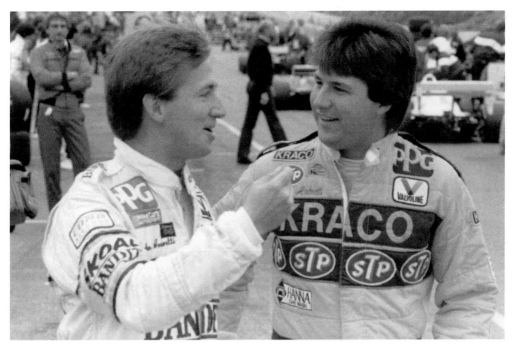

During the late 1980s and early 1990s, the Andretti family could be seen with three and sometimes four family members driving in a race. On the left is John Andretti, and on the right is his cousin Michael Andretti. (Courtesy Mazda Raceway.)

"I'm not happy with you." Well, that may not be exactly what he said, but the driver of No. 52 lets a fellow competitor know how he feels. Even amateur drivers get worked up. (Courtesy Mazda Raceway.)

George Follmer was another driver to win both the Can-Am and Trans-Am titles. When Mark Donahue was injured in testing prior to the second race of the 1972 Can-Am season, team owner Roger Penske chose Follmer as his replacement. Follmer took to the Turbo Panzer like a duck to water, winning five races (including Laguna) and the series championship. (Courtesy Mazda Raceway.)

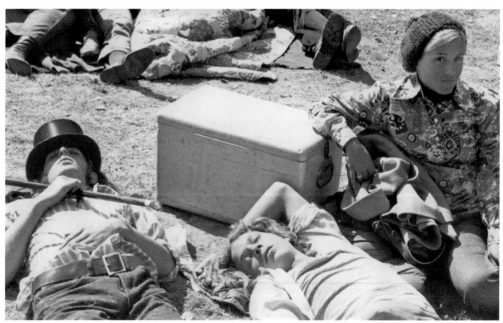

Watching racing all day can wear you out. Here one sees the results of a hard day, as spectators take a break. Why the fan on the left is wearing a top hat and has a cane no one knows. The fan leaning on the cooler doesn't seem to be happy with the day's events. Maybe the other two drank all the beer. (Courtesy Mazda Raceway.)

THE PEOPLE

Event Programs

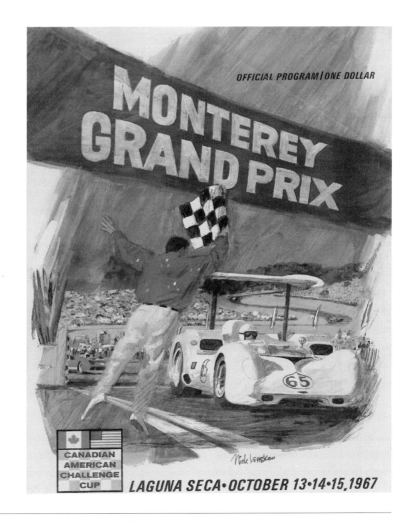

Phil Hill is center stage on the cover of the 1967 Can-Am race program. Hill won the first heat of the 1966 Can-Am event at Laguna. (Courtesy Mazda Raceway.)

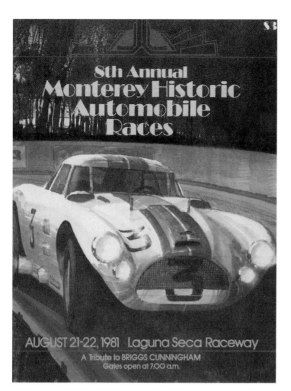

This is the program cover for the 1981 Monterey Historic race. The event was a tribute to American racing legend Briggs Cunningham and his cars. (Courtesy Mazda Raceway.)

The 1968 Can-Am race program cover is pictured here. Many program covers such as this had great drawn artwork for the covers. This cover shows Bruce McLaren crossing the finish line after winning the 1967 race. (Courtesy Mazda Raceway.)

The program cover for the 1975 Monterey Superbike International has American Kenny Roberts at work. Roberts would win the event for the second year in a row. (Courtesy Mazda Raceway.)

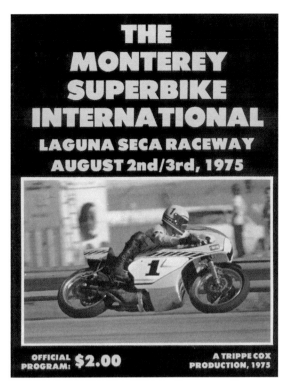

Here is the program cover for the 1967 USRRC race. The McLaren of Lothar Motschenbacher would win this race. (Courtesy Mazda Raceway.)

The 1968 USRRC race was won by Mark Donahue. This was the last USRRC event held at the track as the series folded at the end of the year. (Courtesy Mazda Raceway.)

The program for the 1966 USRRC race is shown; on the cover are the Lola T70 of Walt Hansgen and the Chaparral of Hap Sharp. (Courtesy Mazda Raceway.)

This is the program cover for the 1987 IMSA Nissan Monterey Triple Crown. (Courtesy Mazda Raceway.)

The 1972 Kawasaki Superbike race was won by Cal Rayborn on a Harley Davidson. The program cover is shown here. (Courtesy Mazda Raceway.)

The 1977 Can-Am race was the first year of the new Can-Am series for re-bodied Formula 5000 racecars. (Courtesy Mazda Raceway.)

The Datsun Monterey Triple Crown program cover from 1981 is featured. The new Lola T600 GTP machine of Brian Redman takes center stage here. This was the first race for a GTP machine, and the Lola won the race. (Courtesy Mazda Raceway.)

International racing returns to Laguna in 2006—this is the cover for the Red Bull U.S. MotoGP. American Nicky Hayden went on to win the MotoGP title that year. (Courtesy Mazda Raceway.)

The cover for the A1GP race in 2006 is shown here. The weekend offered great racing but terrible weather. (Courtesy Mazda Raceway.)

This is the program cover for the 1974 Camel GT Challenge race. This was the first IMSA race held at Laguna. (Courtesy Mazda Raceway.)

The program for the 1969 Formula Continental race is shown here. The weekend offered races for Formula B and larger Formula A cars. Sam Posey won the Formula A race. (Courtesy Mazda Raceway.)

EVENT PROGRAMS

A program cover for the 1963 Laguna Seca Road Racing Championship Races is pictured. Chuck Parsons, driving a Lotus 23B, won the event. (Courtesy Mazda Raceway.)

Below, the Monterey Grand Prix program cover for the 1975 event shows Jackie Oliver behind the wheel of his UOP Shadow. (Courtesy Mazda Raceway.)

Bruce McLaren would win the 1969 Monterey Castrol Grand Prix Can-Am race. (Courtesy Mazda Raceway.)

This program cover was for the Monterey Pacific Grand Prix in 1963. Dave McDonald, driving a King Cobra, would win this race. (Courtesy Mazda Raceway.)

EVENT PROGRAMS

This program cover was for the 1964 Monterey Grand Prix, which was won by Roger Penske driving a Chaparral. (Courtesy Mazda Raceway.)

A cover of the program for the 1965 Monterey Grand Prix is shown here. Walt Hansgen driving a Lola T70 won that race. (Courtesy Mazda Raceway.)

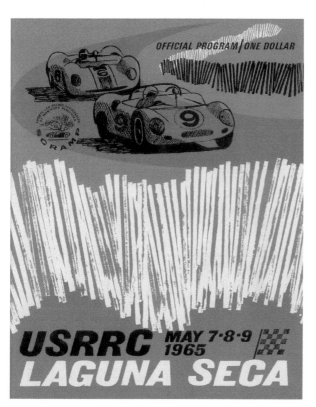

Jim Hall in his Chaparral won the 1965 USRRC race. Hall's car was unique at the time in that it used an automatic transmission. (Courtesy Mazda Raceway.)

Below, the program cover for the 1972 Can-Am race is depicted. The cover shows a McLaren leading a Porsche. The race didn't turn out that way, as a pair of Roger Penske–owned Porsche 917/10s took the first two positions. (Courtesy Mazda Raceway.)

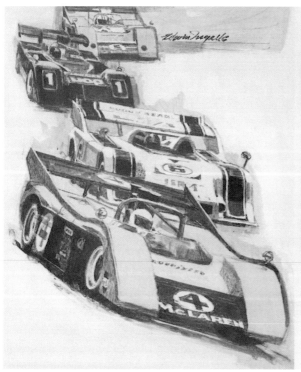

The first Championship Auto Racing Teams (CART) event held at Laguna was in 1983. The cover program shows Bobby Rahal behind the wheel of his March. (Courtesy Mazda Raceway.)

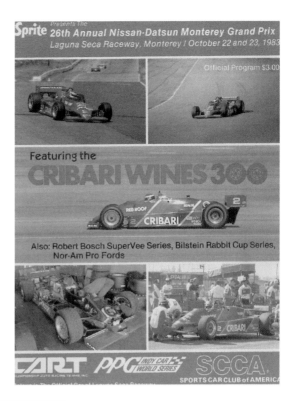

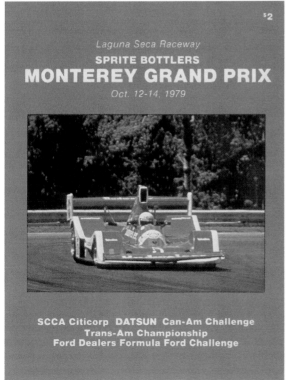

This program cover was for the 1979 Monterey Grand Prix Can-Am race. Bobby Rahal won this race as well, driving a Prophet Chevrolet. (Courtesy Mazda Raceway.)

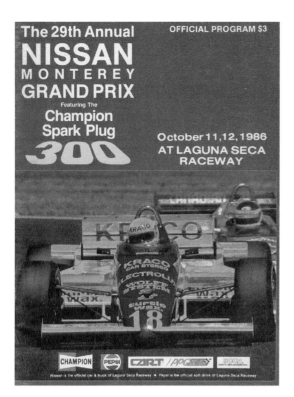

The cover for the 1986 Monterey Grand Prix program is shown here. Bobby Rahal won the CART race, his third event win in a row. (Courtesy Mazda Raceway.)

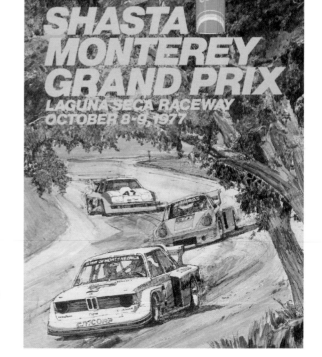

The BMW 320I driven by David Hobbs leads the field on the program cover for the 1977 Shasta Monterey Grand Prix. Hobbs would win the race. (Courtesy Mazda Raceway.)

The cover of the 2nd Annual Monterey Historic races, held in 1975, is pictured. Alfa Romeo was the featured manufacturer this year. (Courtesy Mazda Raceway.)

Below, the cover for the June Sprints in 1974 shows the "Giant Killer," Walt Maas, in his Datsun 240Z leading a Group 44 Triumph and Rich Sloma's Corvette. Back in the 1970s, this was a huge amateur event. (Courtesy Mazda Raceway.)

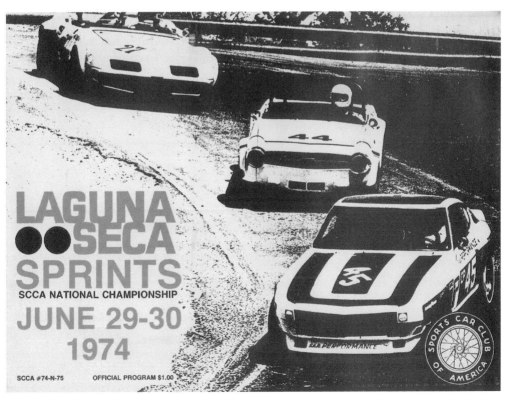

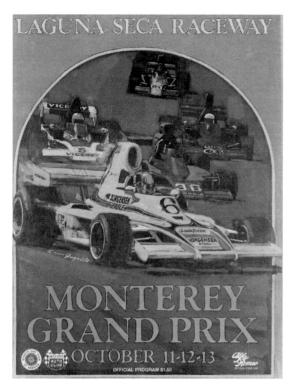

The 1974 Formula 5000 race was the first headlining Formula 5000 event at Laguna to be called the Monterey Grand Prix. (Courtesy Mazda Raceway.)

The 2005 Rolex Monterey Historic Automobile Race program shows that Chaparral returned to Laguna after an absence of over 30 years. (Courtesy Mazda Raceway.)

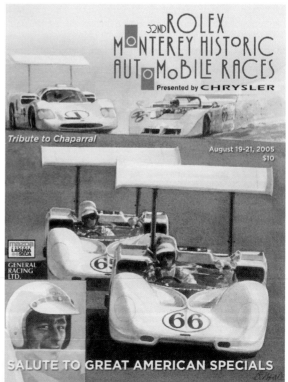

This program cover was for the L&M Championship Formula 5000 race in 1973. The race was won by future F1 World Champion Jody Scheckter driving a Trojan. (Courtesy Mazda Raceway.)

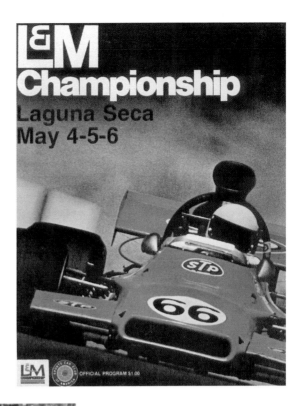

The program cover for the 1978 Monterey Grand Prix is featured here. Leading the cars on the pace lap is a Triumph. BMW, Porsche, Chevrolet, Datsun, and more had cars entered in the race. (Courtesy Mazda Raceway.)

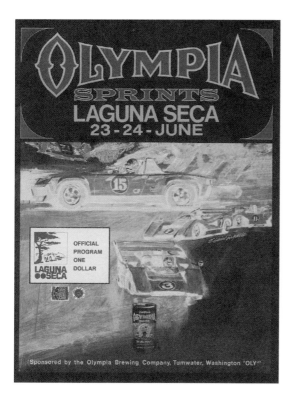

This is the program cover for the Olympia Sprints in 1972. (Courtesy Mazda Raceway.)

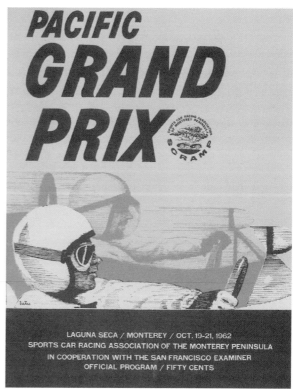

Roger Penske won the 1962 Pacific Grand Prix race in his Zerex Special. (Courtesy Mazda Raceway.)

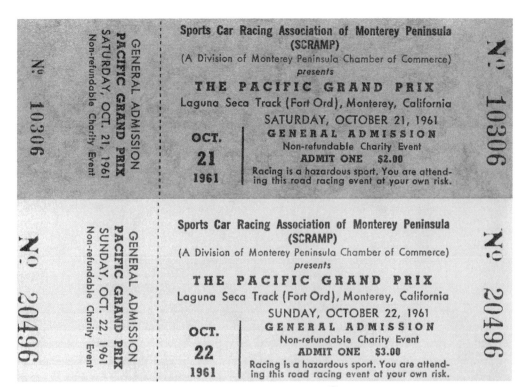

Sports Car Racing Association of Monterey Peninsula
(SCRAMP)
(A Division of Monterey Peninsula Chamber of Commerce)
presents
THE PACIFIC GRAND PRIX
Laguna Seca Track (Fort Ord), Monterey, California
SATURDAY, OCTOBER 21, 1961
OCT. 21 1961 | GENERAL ADMISSION
Non-refundable Charity Event
ADMIT ONE $2.00
Racing is a hazardous sport. You are attending this road racing event at your own risk.

Nº 10306

Sports Car Racing Association of Monterey Peninsula
(SCRAMP)
(A Division of Monterey Peninsula Chamber of Commerce)
presents
THE PACIFIC GRAND PRIX
Laguna Seca Track (Fort Ord), Monterey, California
SUNDAY, OCTOBER 22, 1961
OCT. 22 1961 | GENERAL ADMISSION
Non-refundable Charity Event
ADMIT ONE $3.00
Racing is a hazardous sport. You are attending this road racing event at your own risk.

Nº 20496

A pair of weekend tickets for 1961 Pacific Grand Prix is pictured here. Even then, the tickets state that racing is dangerous and risky. The whole weekend cost $5. (Courtesy Mazda Raceway.)

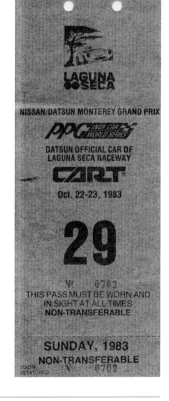

LAGUNA SECA

NISSAN/DATSUN MONTEREY GRAND PRIX

PPG INDY CAR WORLD SERIES

DATSUN OFFICIAL CAR OF LAGUNA SECA RACEWAY

CART

Oct. 22-23, 1983

29

Nº 0702
THIS PASS MUST BE WORN AND IN SIGHT AT ALL TIMES
NON-TRANSFERABLE

SUNDAY, 1983
NON-TRANSFERABLE
0702

Here is a ticket for the first CART race, held in 1983. (Courtesy Mazda Raceway.)

Discover Thousands of Local History Books Featuring Millions of Vintage Images

Arcadia Publishing, the leading local history publisher in the United States, is committed to making history accessible and meaningful through publishing books that celebrate and preserve the heritage of America's people and places.

Find more books like this at
www.arcadiapublishing.com

Search for your hometown history, your old stomping grounds, and even your favorite sports team.